WORLD *of* WONDERS

JIMMY & DENA KATZ

pH powerHouse Books Brooklyn, NY

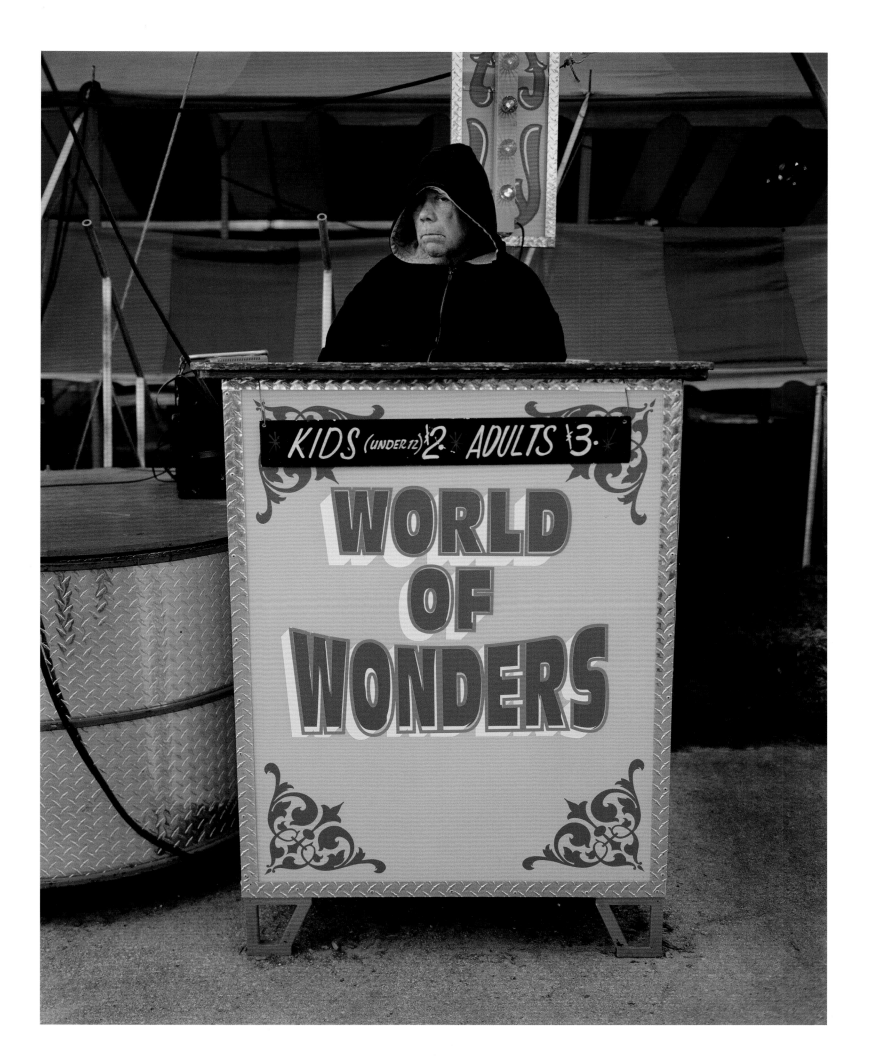

*I*t's showtime! See weird, wonderful, wild and bizarre. The strangest show on earth: the Headless Woman, four-legged dancers, pygmies, Spider Girl, the Girl Who Changes Into a Gorilla, sword swallowers, the Human Blockhead, and they are all ready to meet you. Bring your kids, bring your grandparents, bring your in-laws, bring your outlaws, bring your parole officer, bring everybody inside. If you're in line then you're in time!

Tommy

My name is Ward Hall. I was born in 1930 in Trenton, Nebraska in a little farming community. I left as soon as I found out there was another place. From a small child on I wanted to be a circus performer, but could never do anything athletic. So, I learned to do some magic and eat fire and when I was 14 years old, I had my first job as a prop boy in the circus.

I started in the sideshow business in 1946 when I was 15. I stayed with it because the people in the sideshow were so fascinating to be with and they treated me so good. Also, I saw the prospects of making some money in the sideshow business. I bought my first sideshow in 1951 and I've been going ever since then.

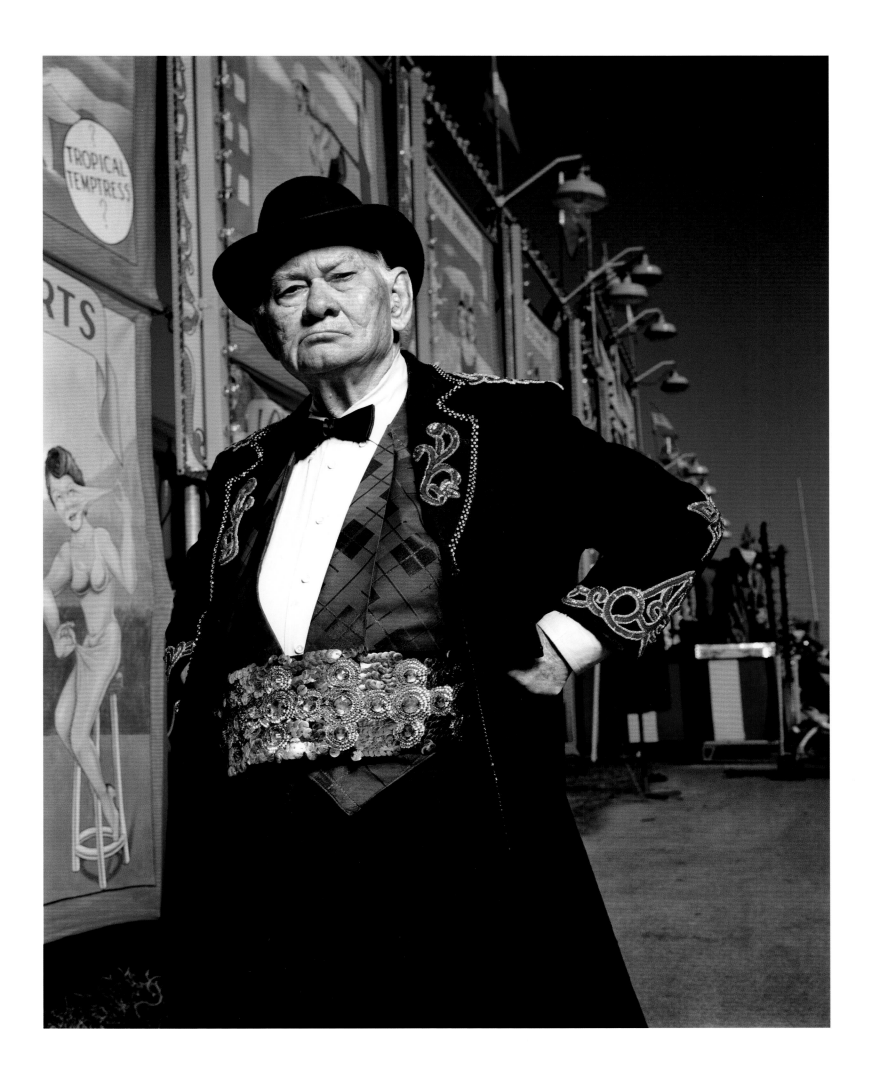

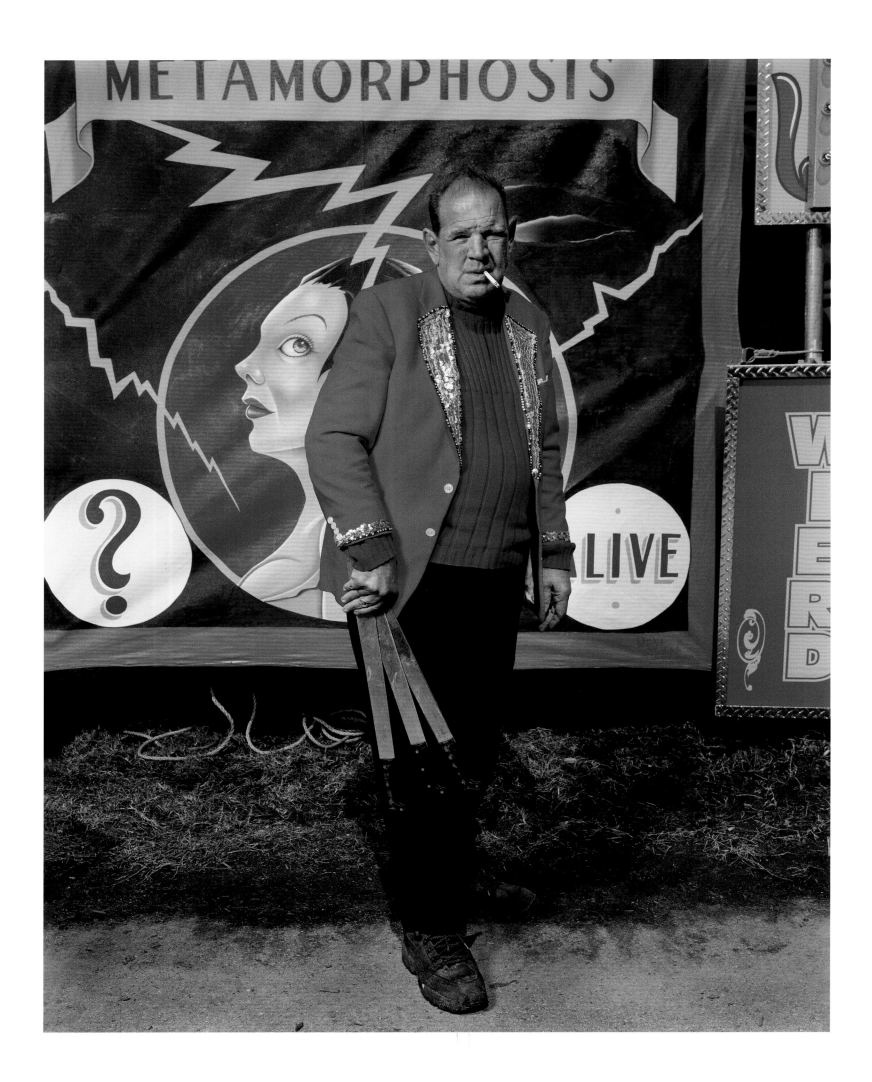

I'm 59 and I'm from Buffalo. I've wanted to do this since I was four. Some kids want to be firemen, some kids want to be policemen; I always knew this is what I wanted to do. I have no idea why. I have no family linkage, no lineage. It's really strange. I've never figured it out. I worked for one summer on kiddie rides at a carnival. My folks thought I'd do it for two weeks and come home. They had a directory of show operators. I wrote to all of them. When I got out of school, I had some money and Ward had run short. In November, 1966, we made a deal: we became partners. I was 18.

Chris

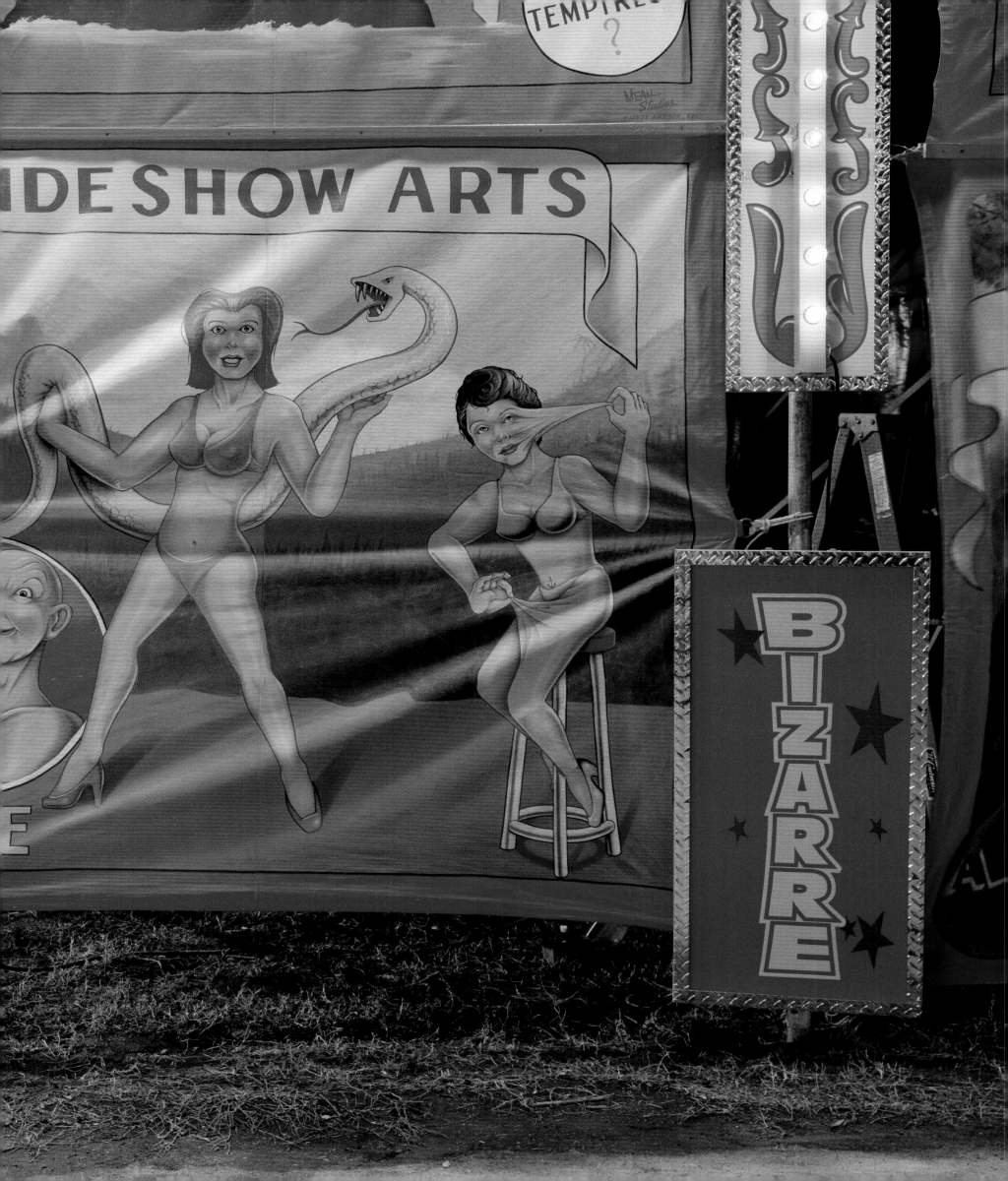

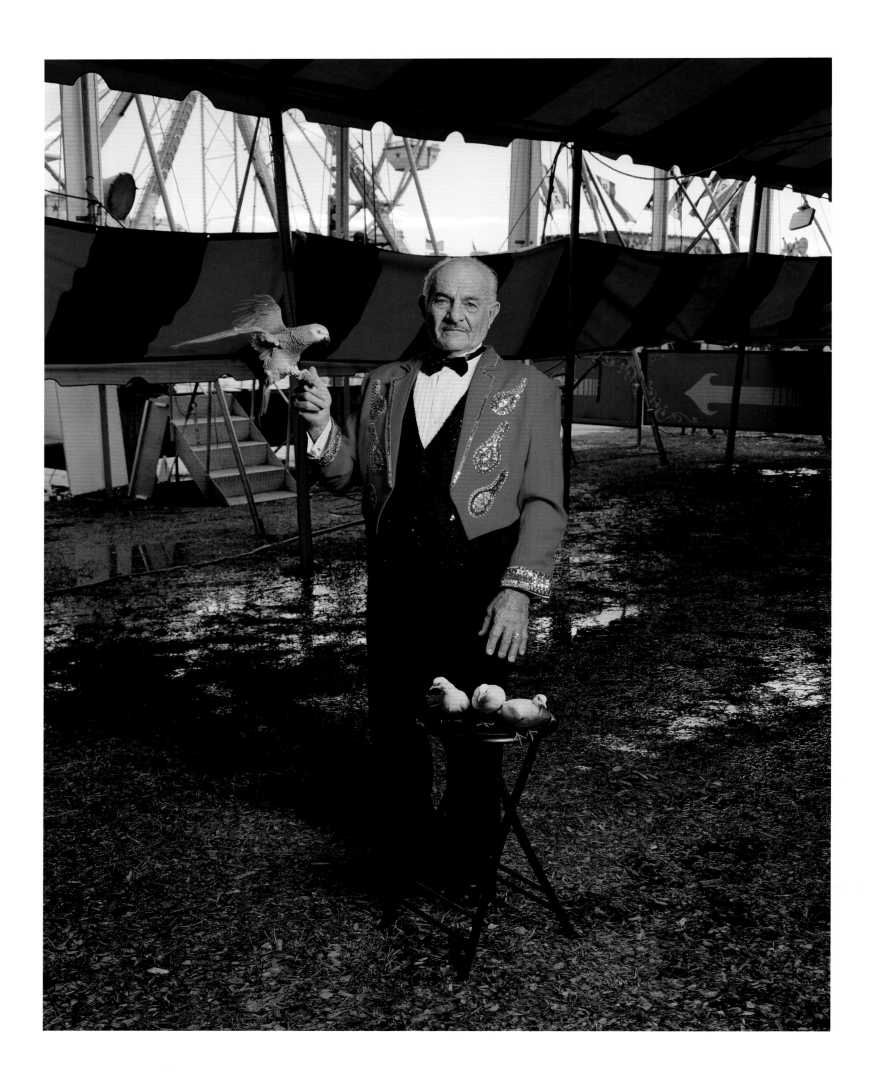

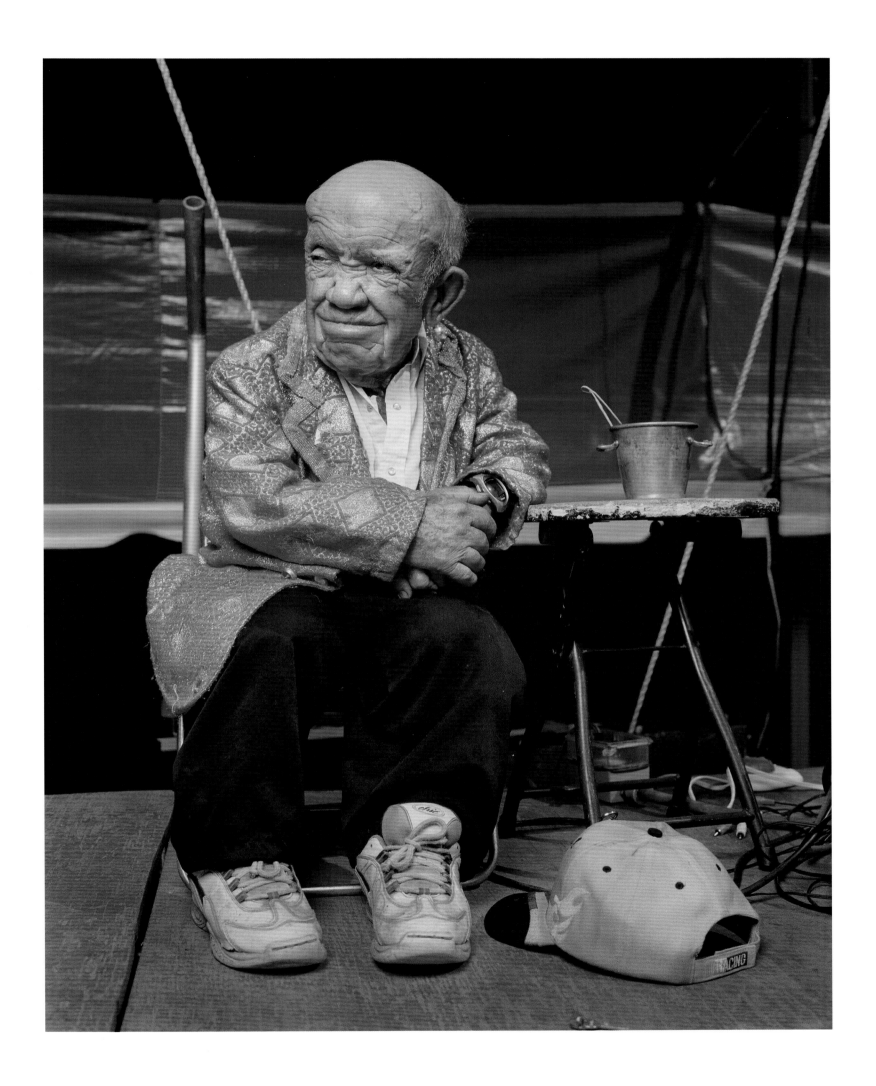

\mathscr{I}'m from **Little Falls, New Jersey.** I've always been kind of shy. After I graduated college, I wanted to join a sideshow, rather than just be some guy with a job who could swallow swords in his living room. The sideshow is dangerous, scary, and impossible. You're going to scream and laugh. I mean, what do you want for $2?

Tommy

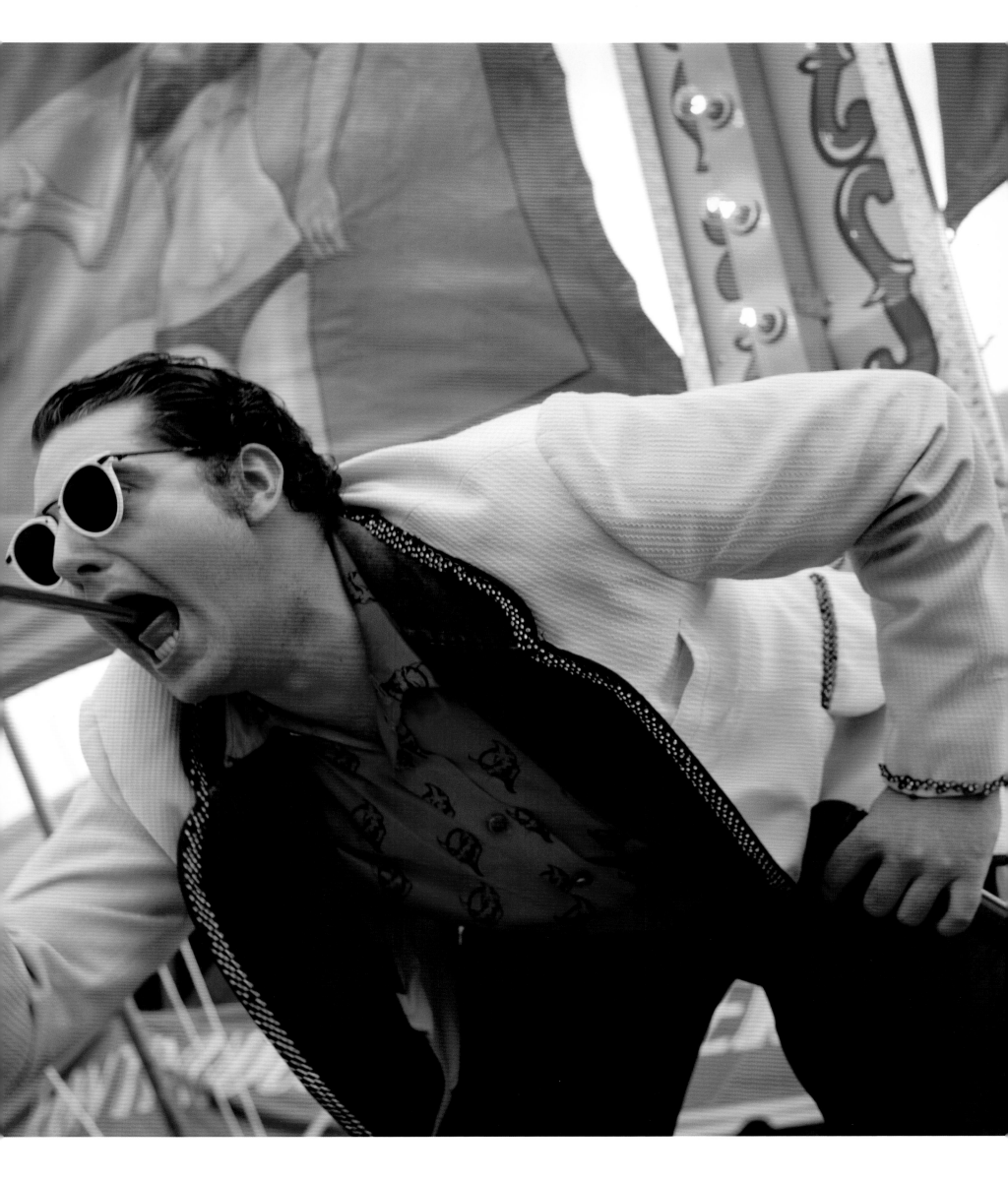

*I*n its heyday, around 1950, there were 104 traveling sideshows touring in America. Today, The World of Wonders is the only one left and it's a shame because this is an American institution.

Ward

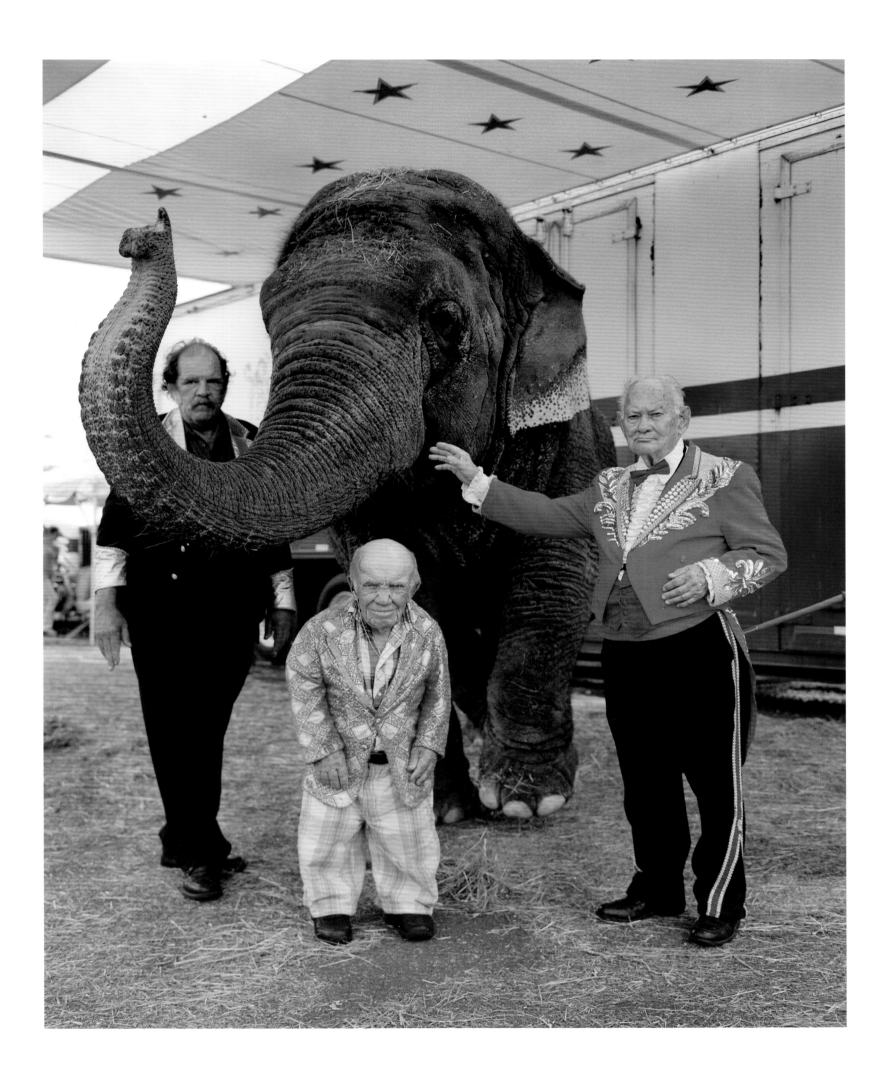

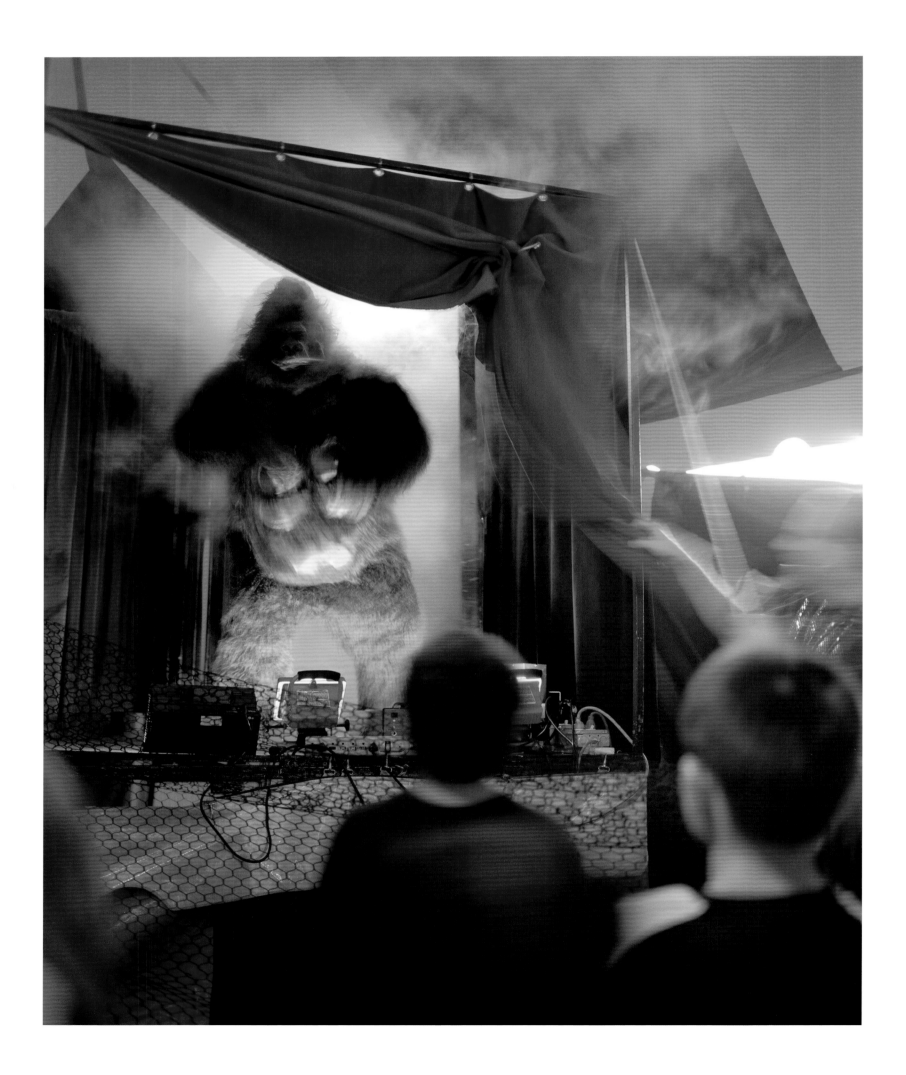

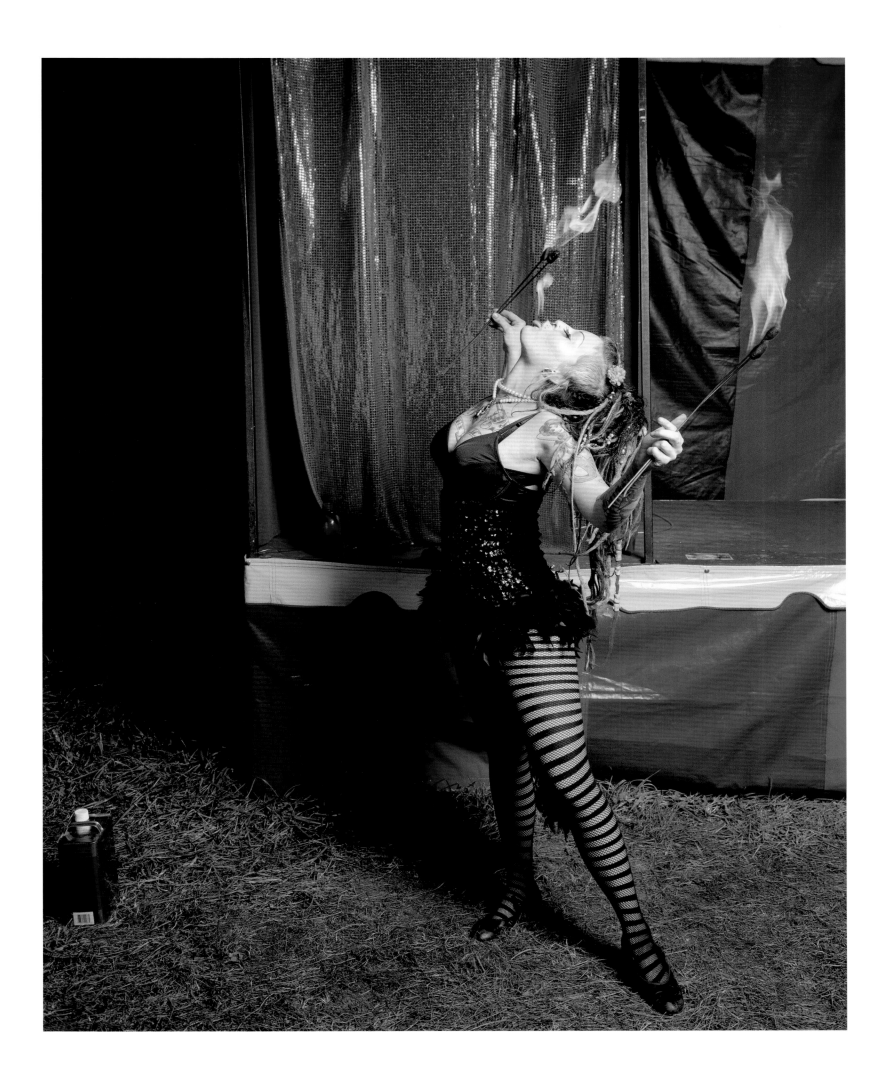

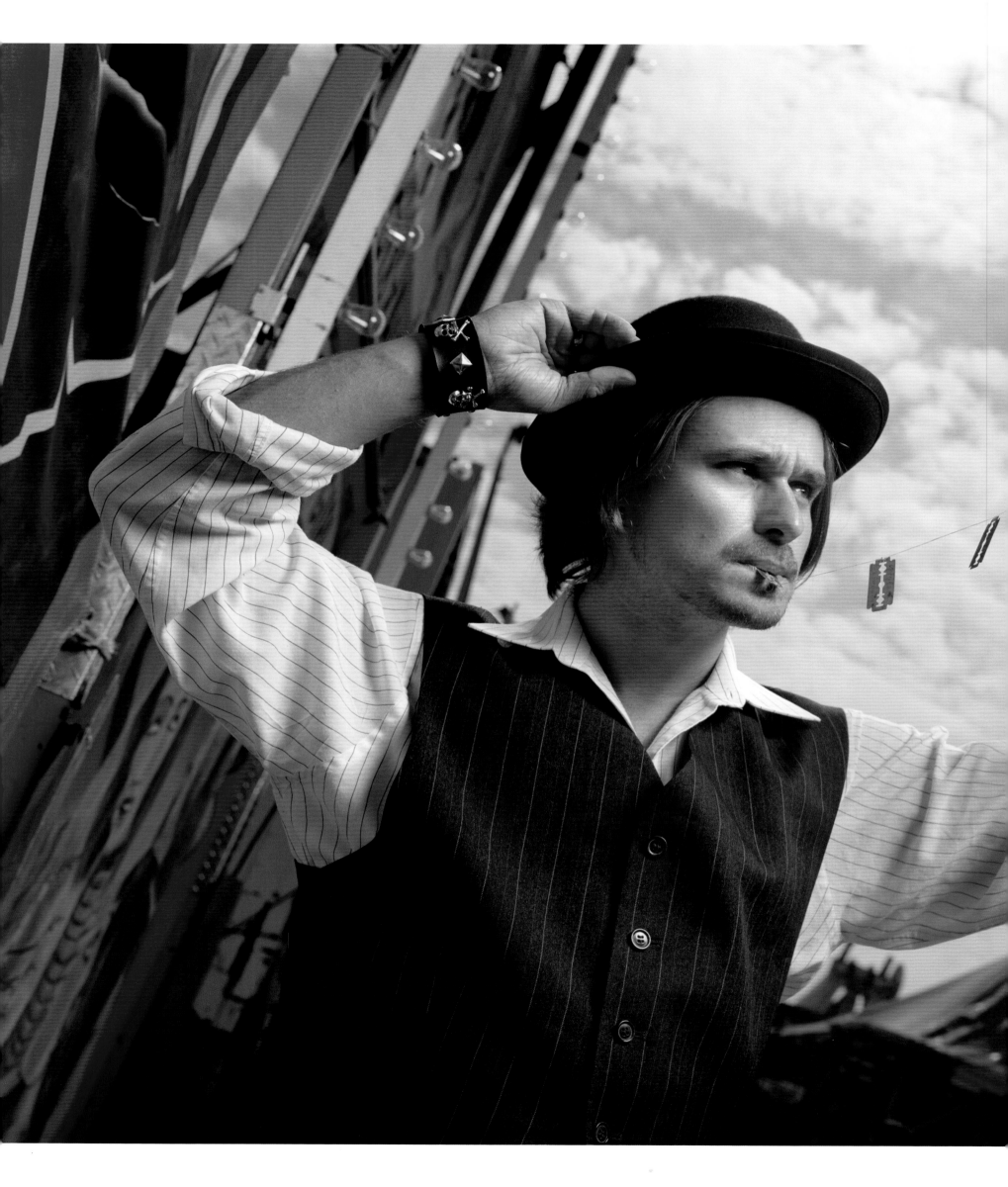

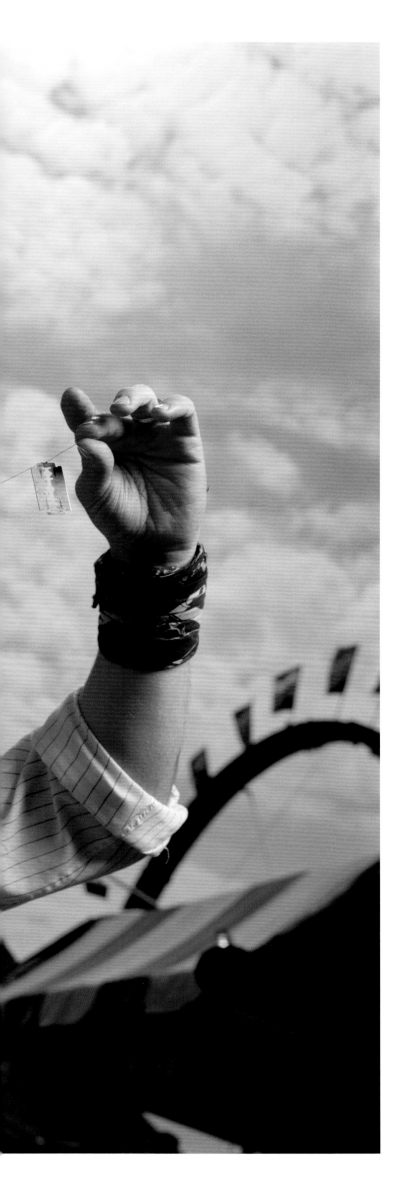

*I*t's a kids' show for the whole family. For one moment those people are nine years old again.

Elton

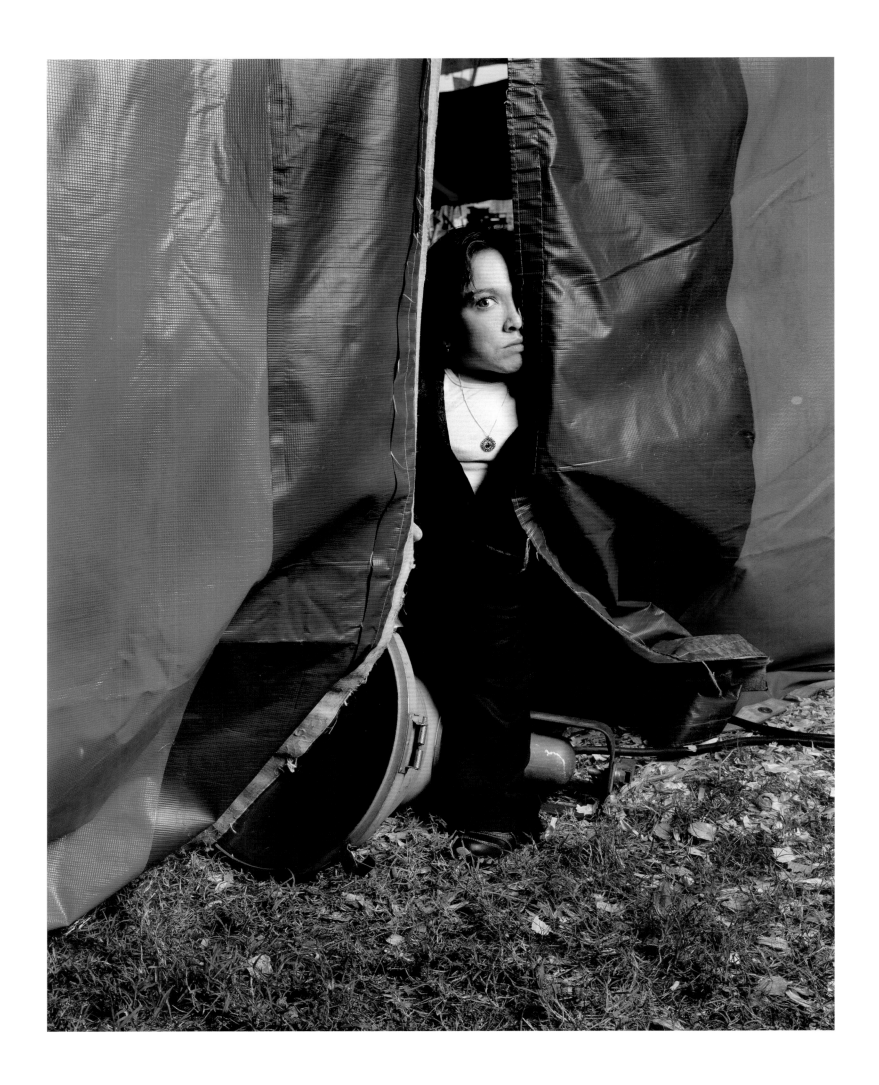

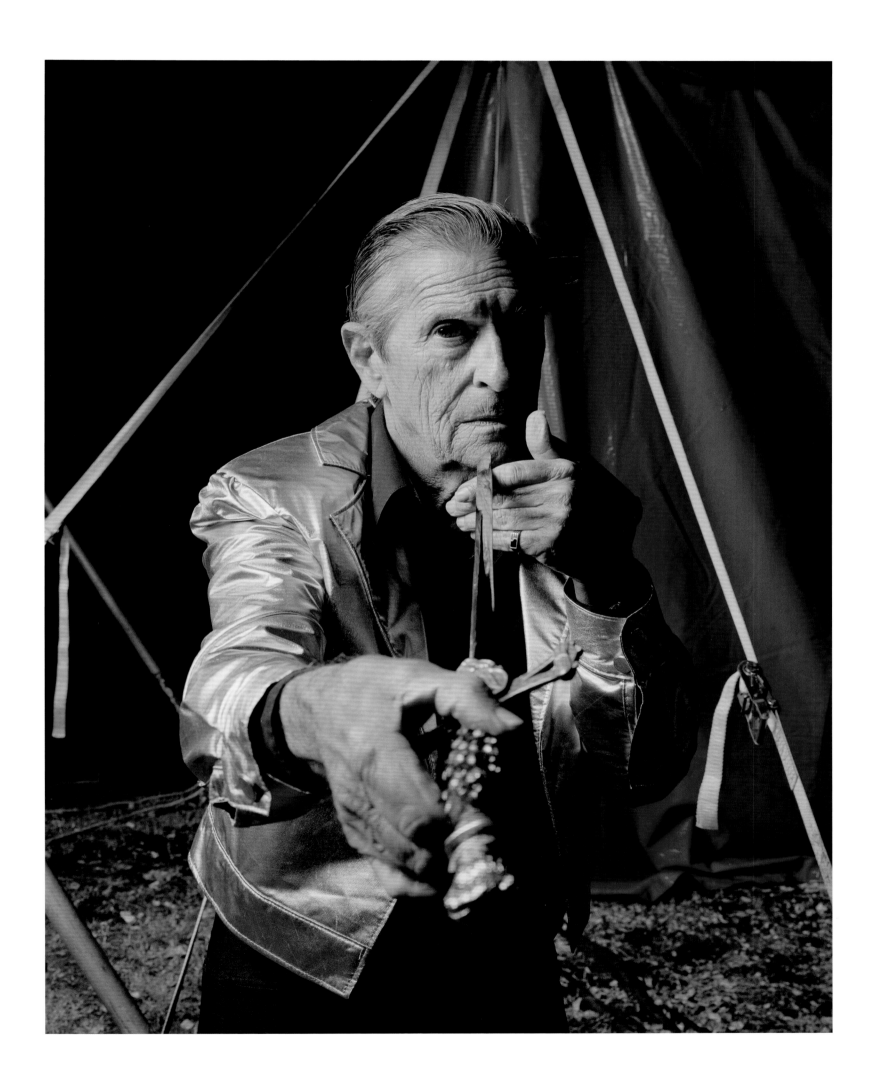

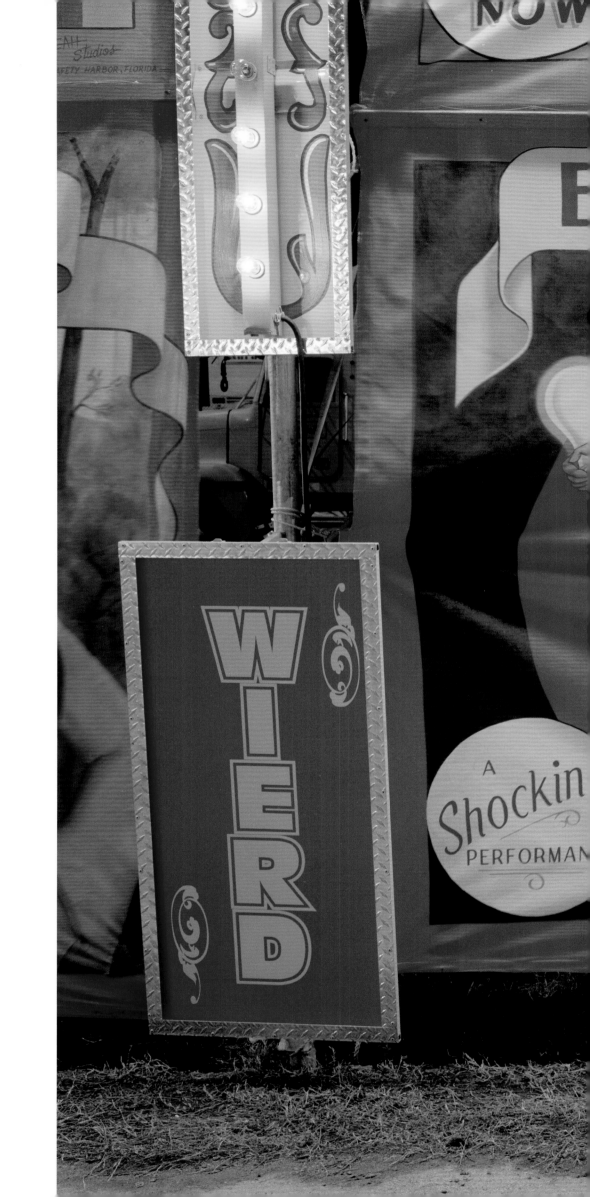

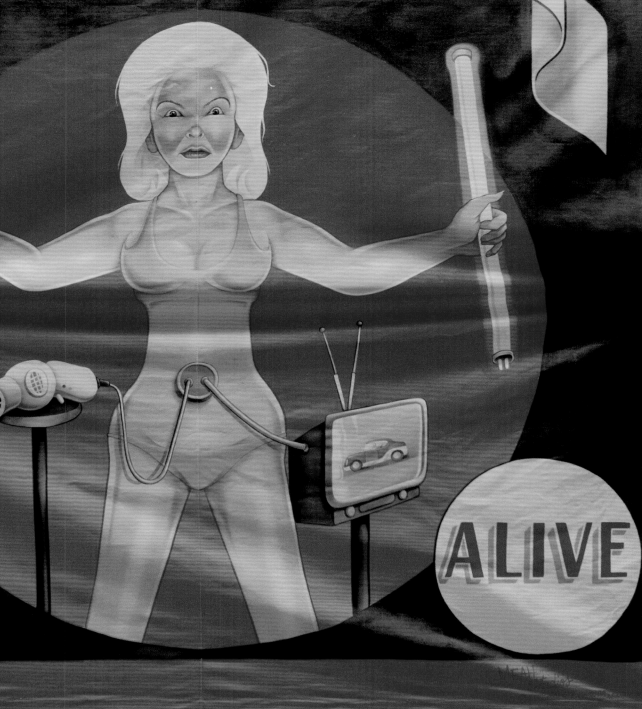

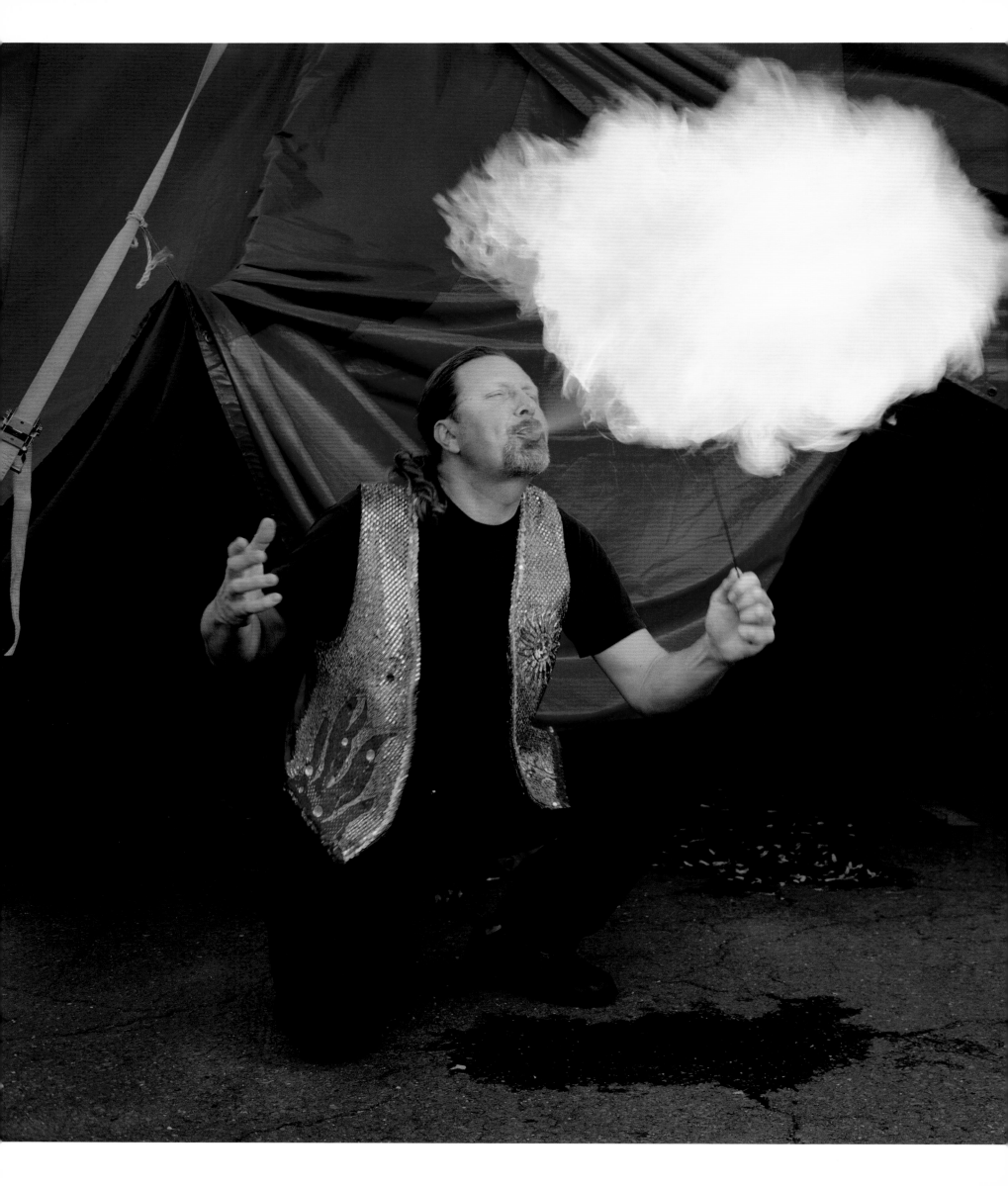

*W*hen you're home, driving down the highway and breathing diesel fumes, it makes you remember the scent of the carnival and makes you really miss it.

Chelsea

\mathcal{S}ure, I'm a professional liar. I seem to have a natural talent for that. You heard me talk the front of the show. Do you believe you are going to see a real two-headed woman? It is my job to convince these people that they are going to see these things. I could take a Volkswagen and make you believe it is a Rolls-Royce. If I had another life I'd like to be a trial lawyer or perhaps an evangelical TV minister.

Ward

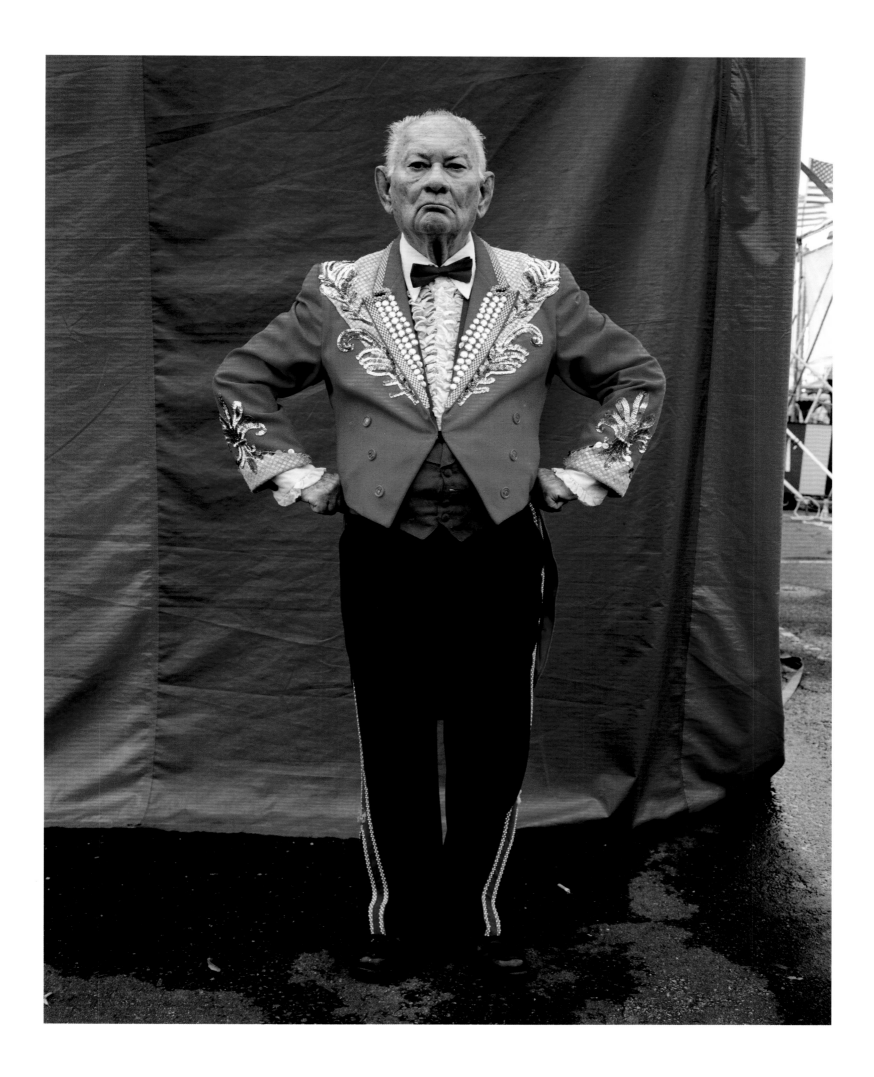

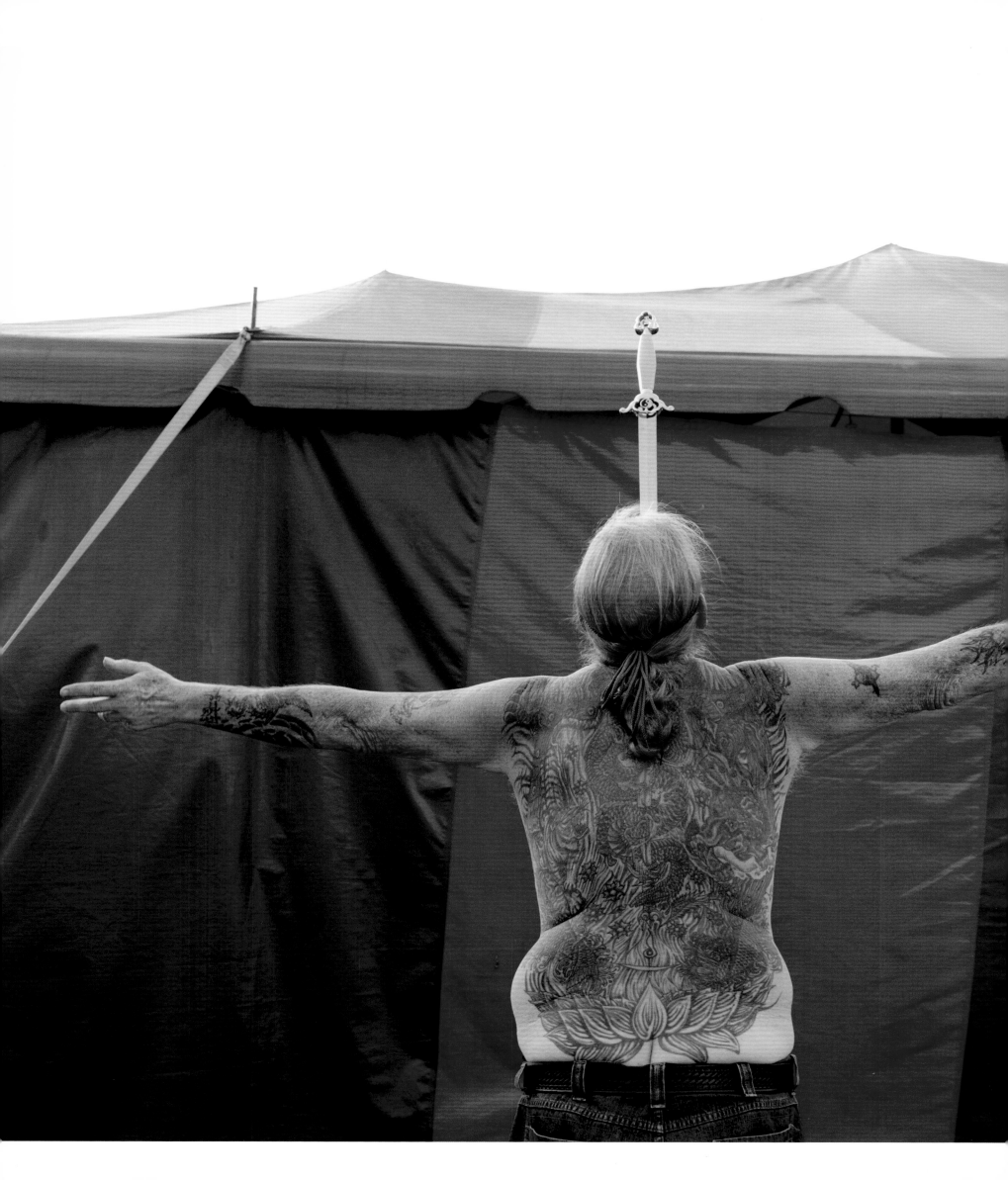

I was born in 1951 on an army camp in New Jersey. I was put up for adoption and raised in orphanages and foster homes in the Philadelphia region. I've been swallowing swords for over 43 years. I'm a three time Guinness World Record holder for sword swallowing. When I teach people how to swallow swords, I tell them one rule of thumb: do not have any doubt or fear, do not hesitate. Just do it.

Red

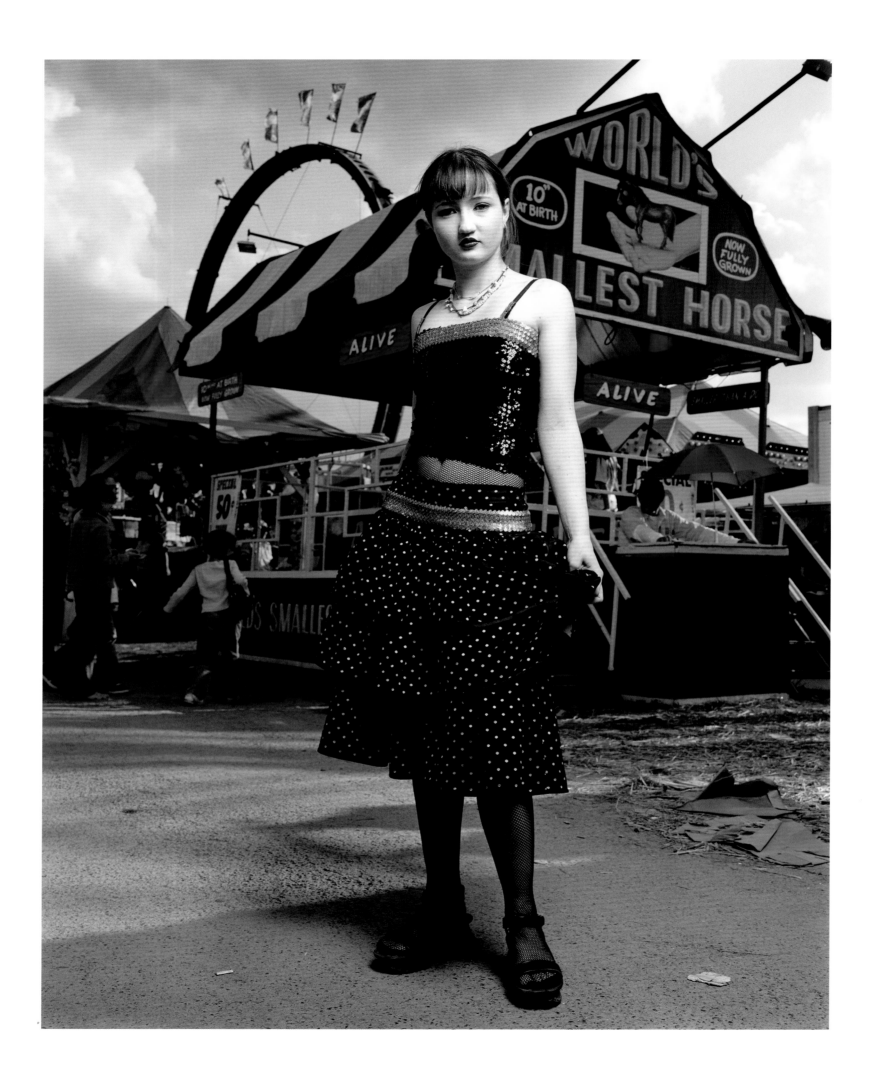

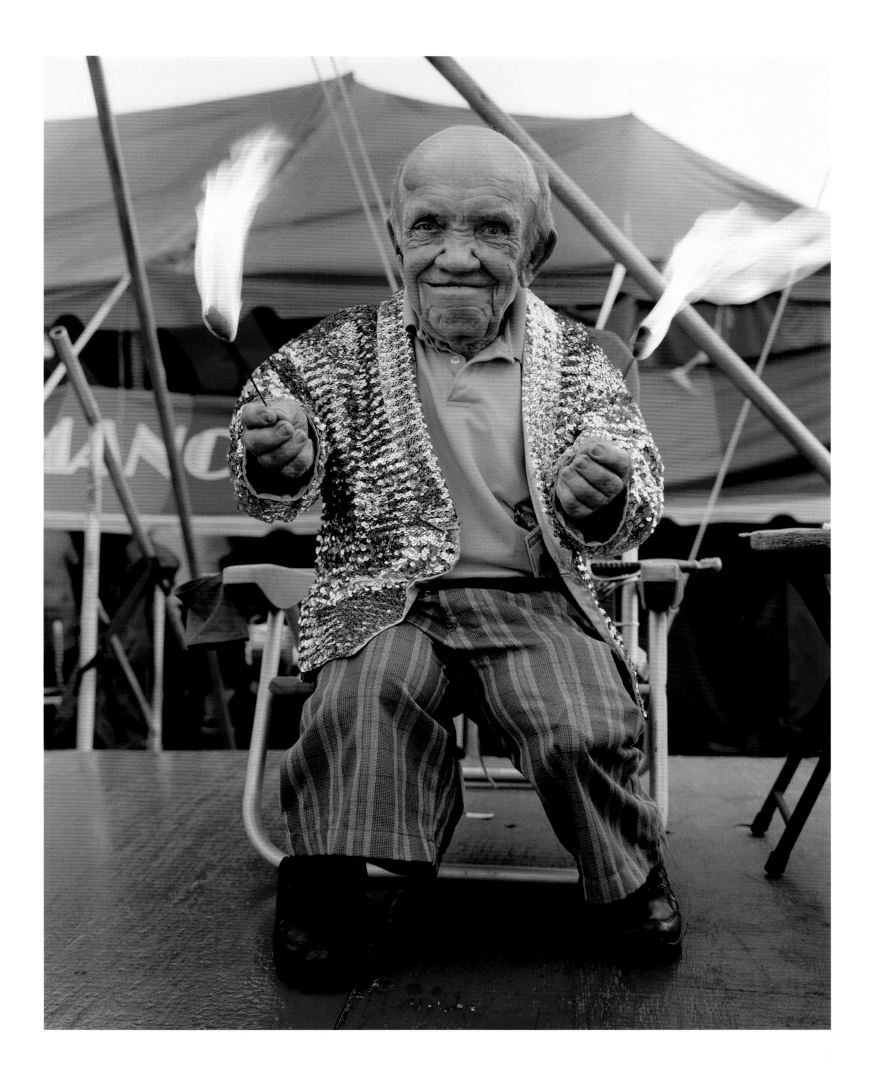

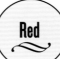 he good part of the carnival industry is that you can
make countless amounts of money in a matter of minutes.

Red

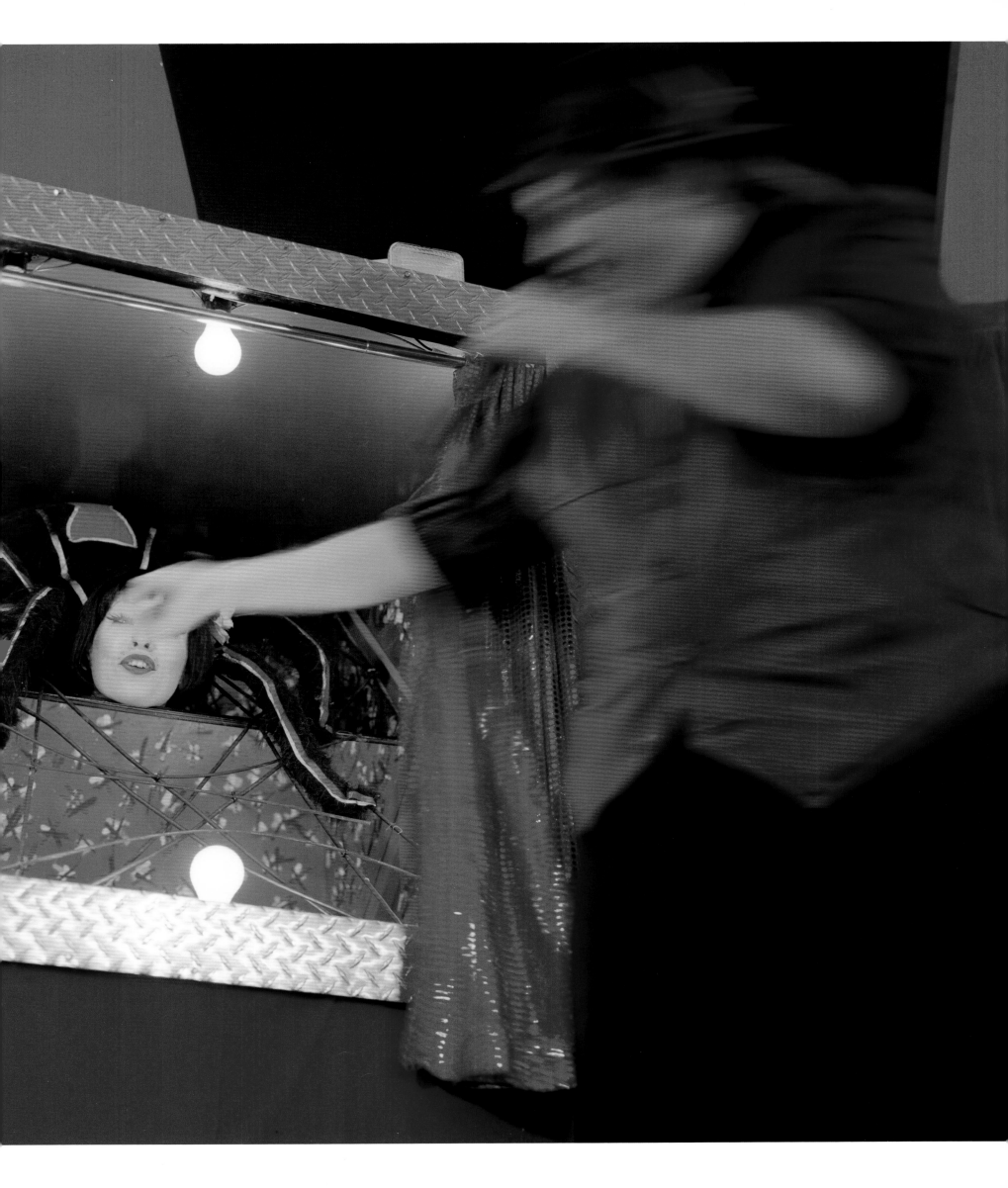

We have the only classic sideshow left in the business and we don't try to modernize it. When this one closes I don't think there will be another one. It's the end of the era.

Ward

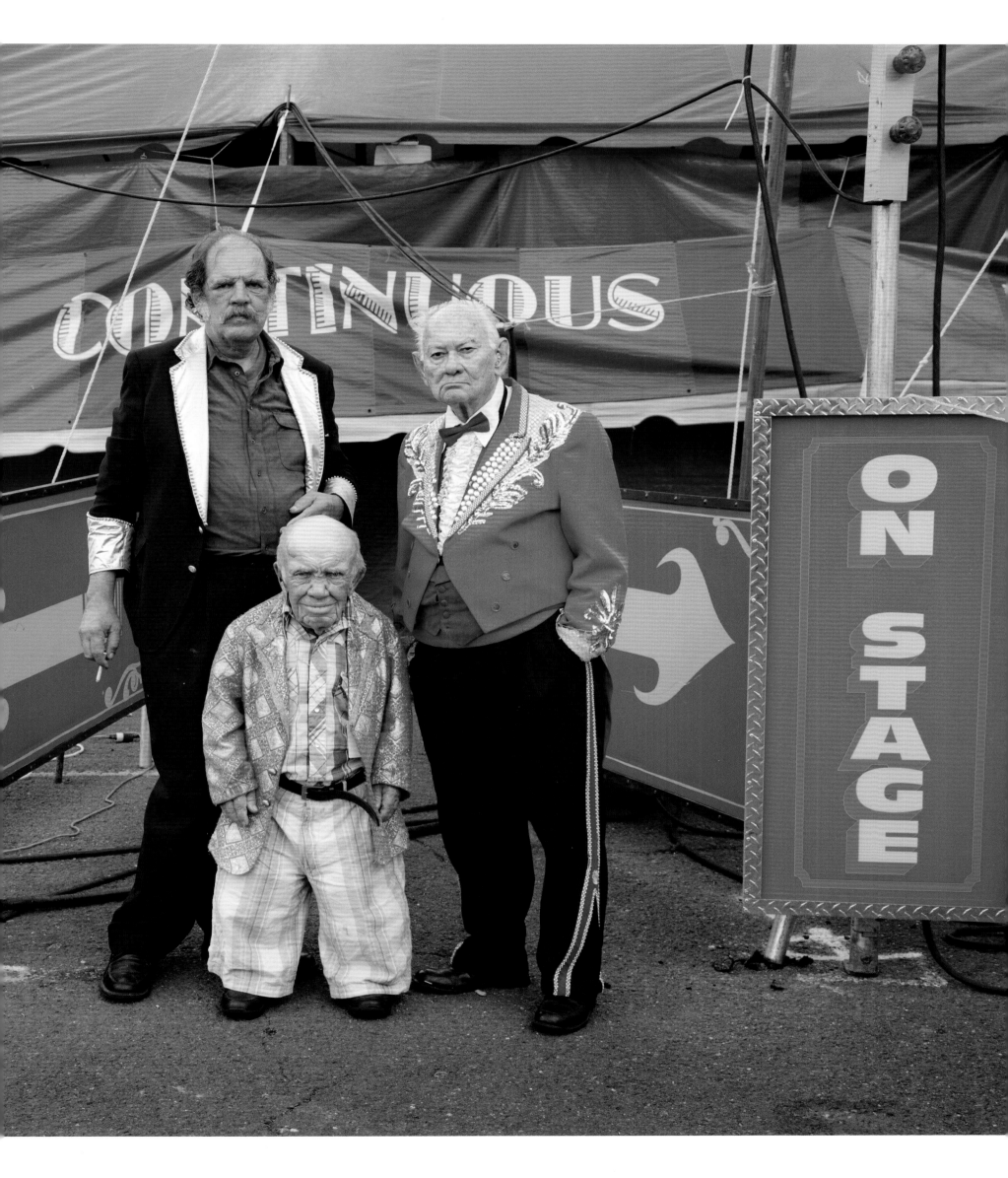

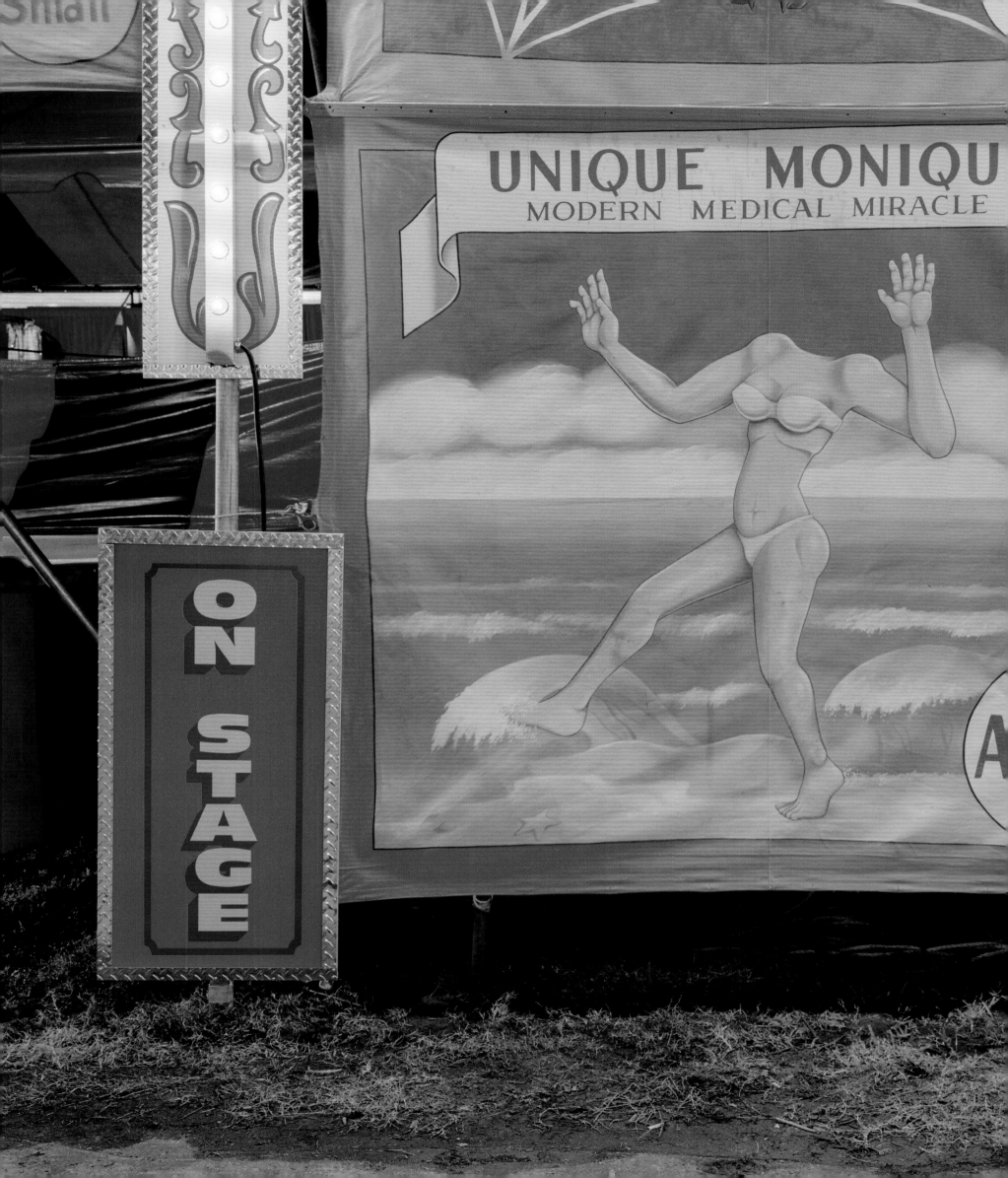

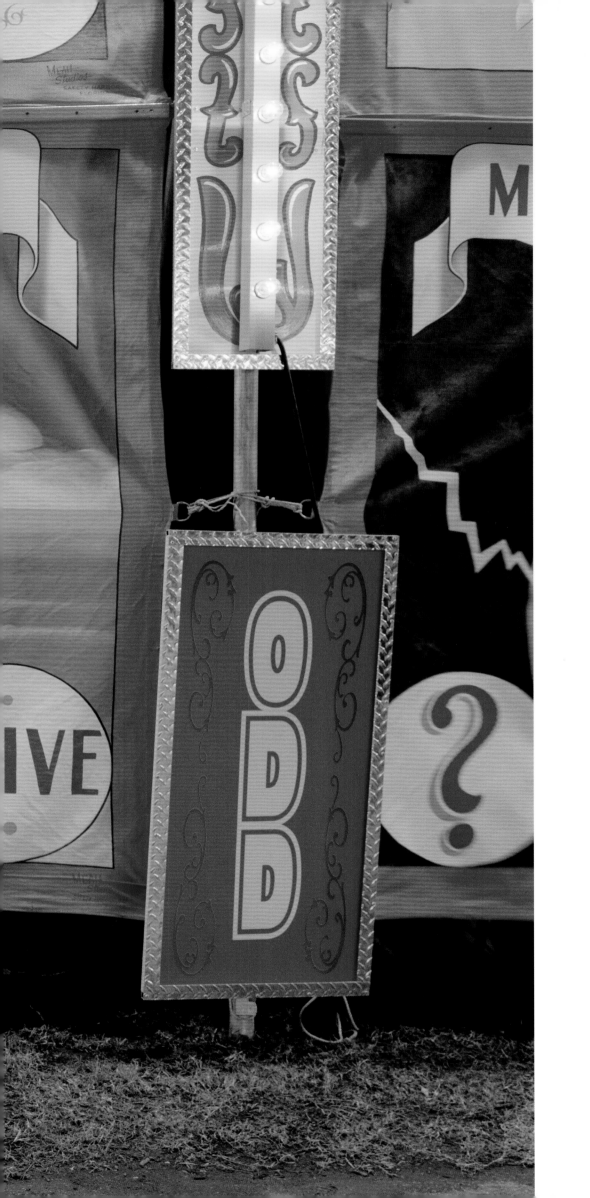

\mathcal{B}efore World of Wonders I was working at
a Starbucks in a shopping mall and I had to suppress
myself a lot.

Chelsea

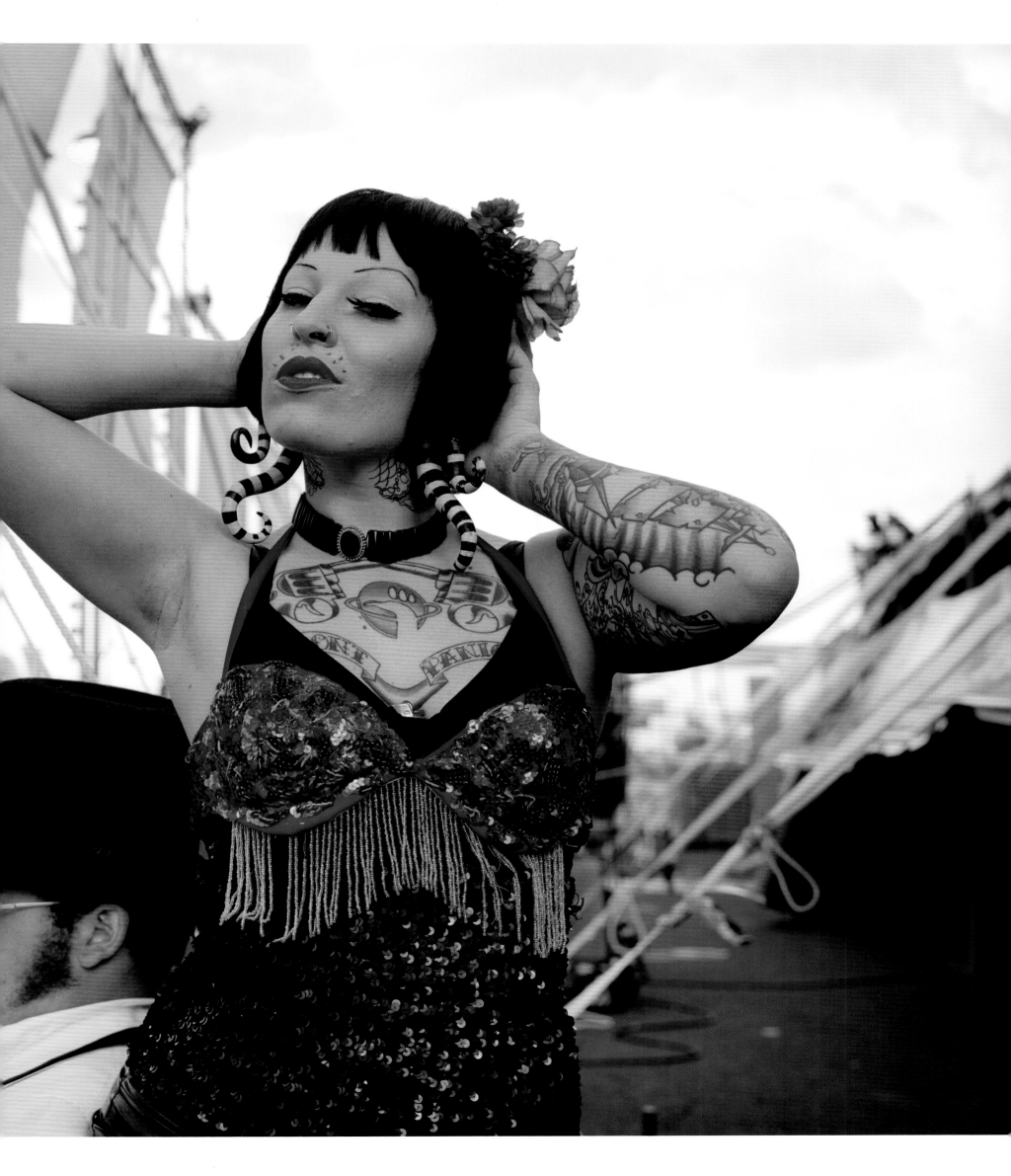

\mathscr{I} went to school for about six weeks, but they weren't teaching me what I wanted to learn, like how to tie a half-hitch on a guy-rope around a tent stake.

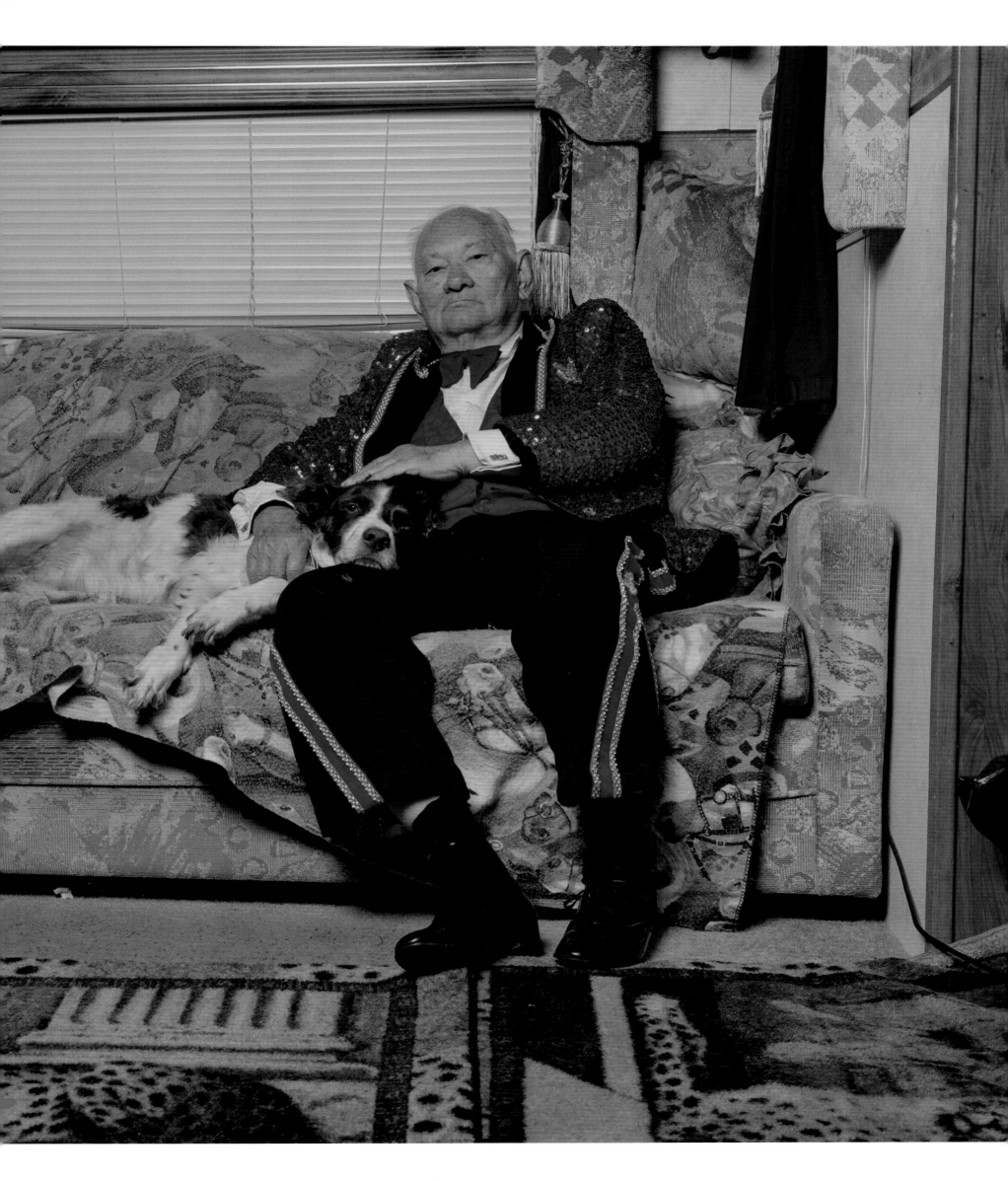

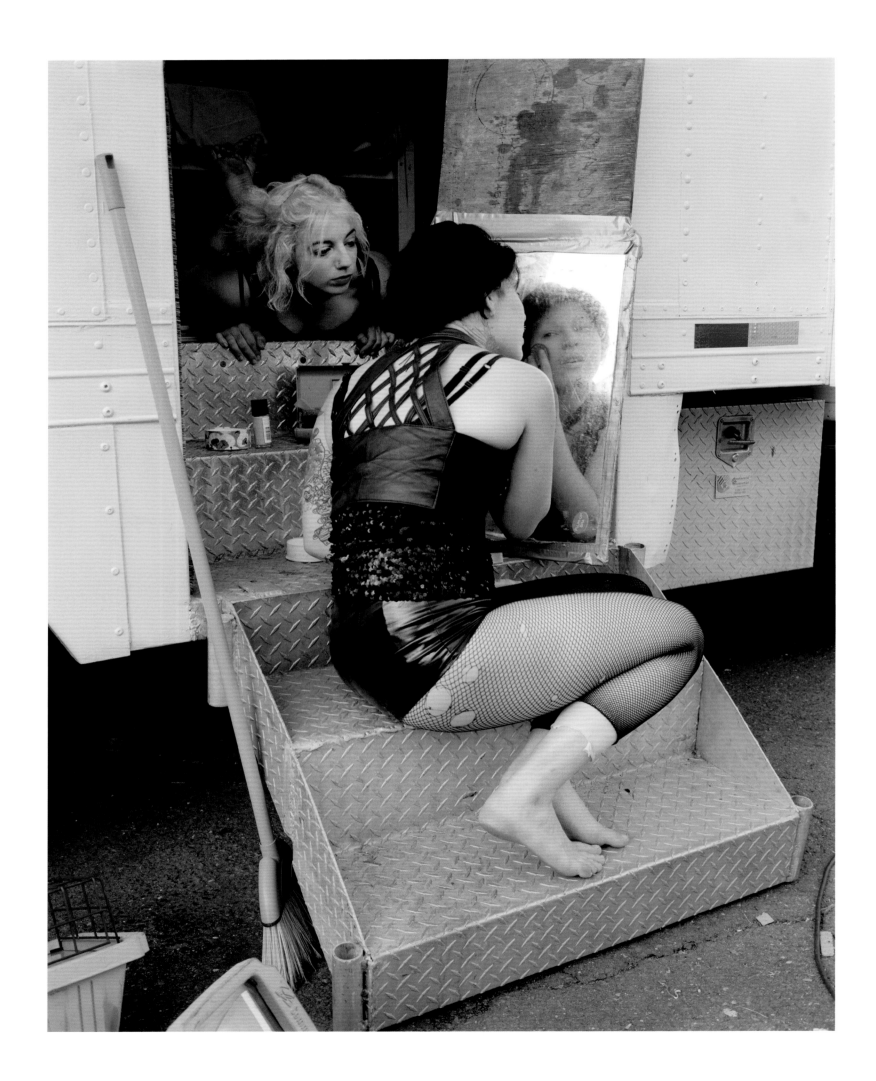

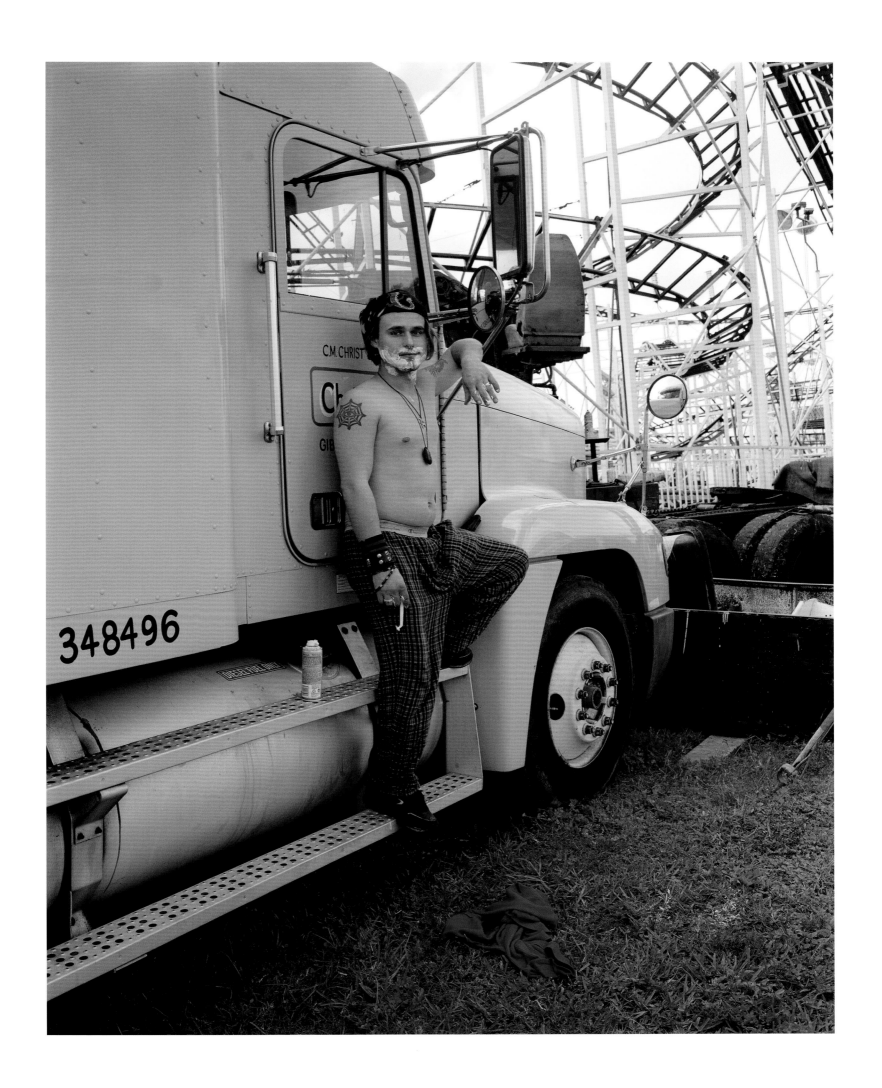

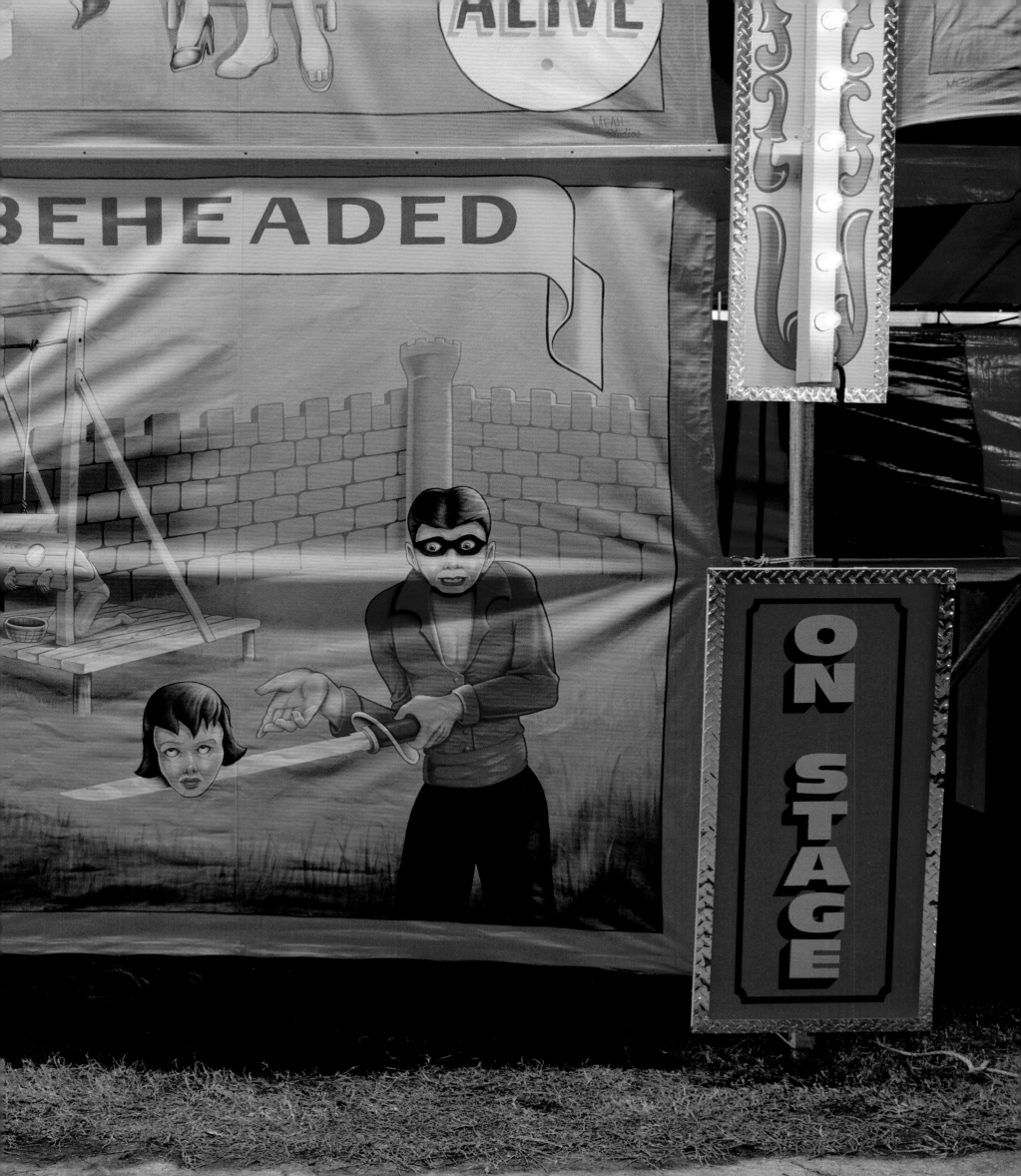

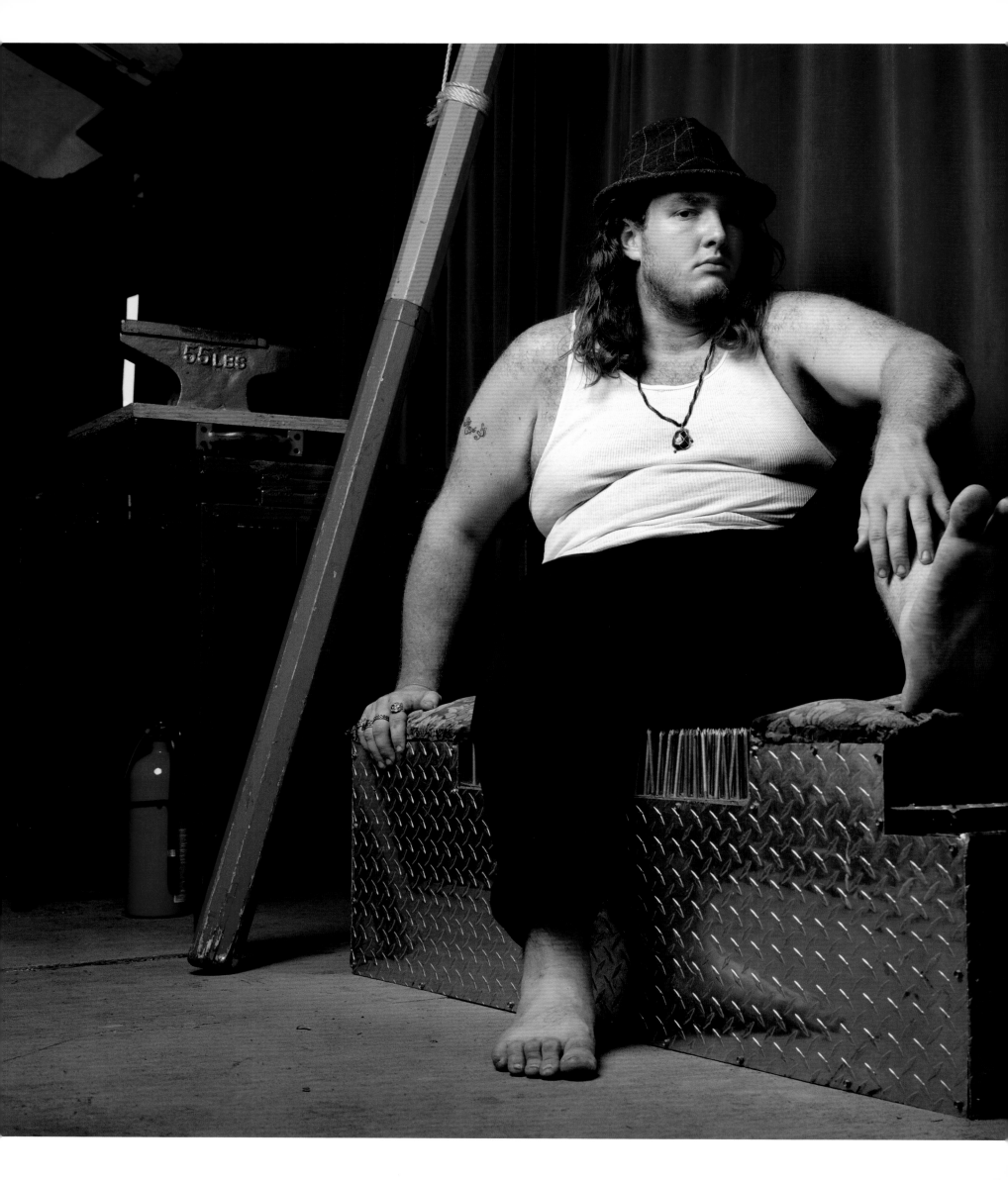

I hope some young person who has the ambition and energy to do this business will take it over.

Ward

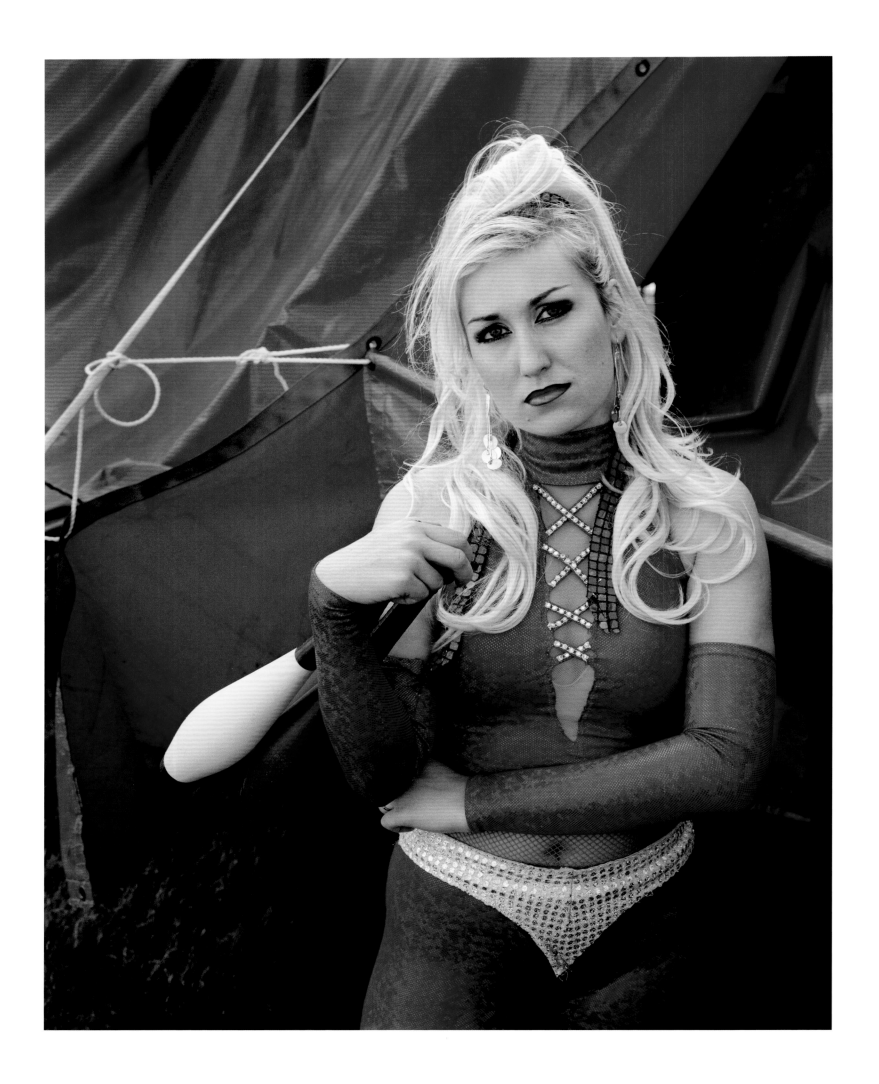

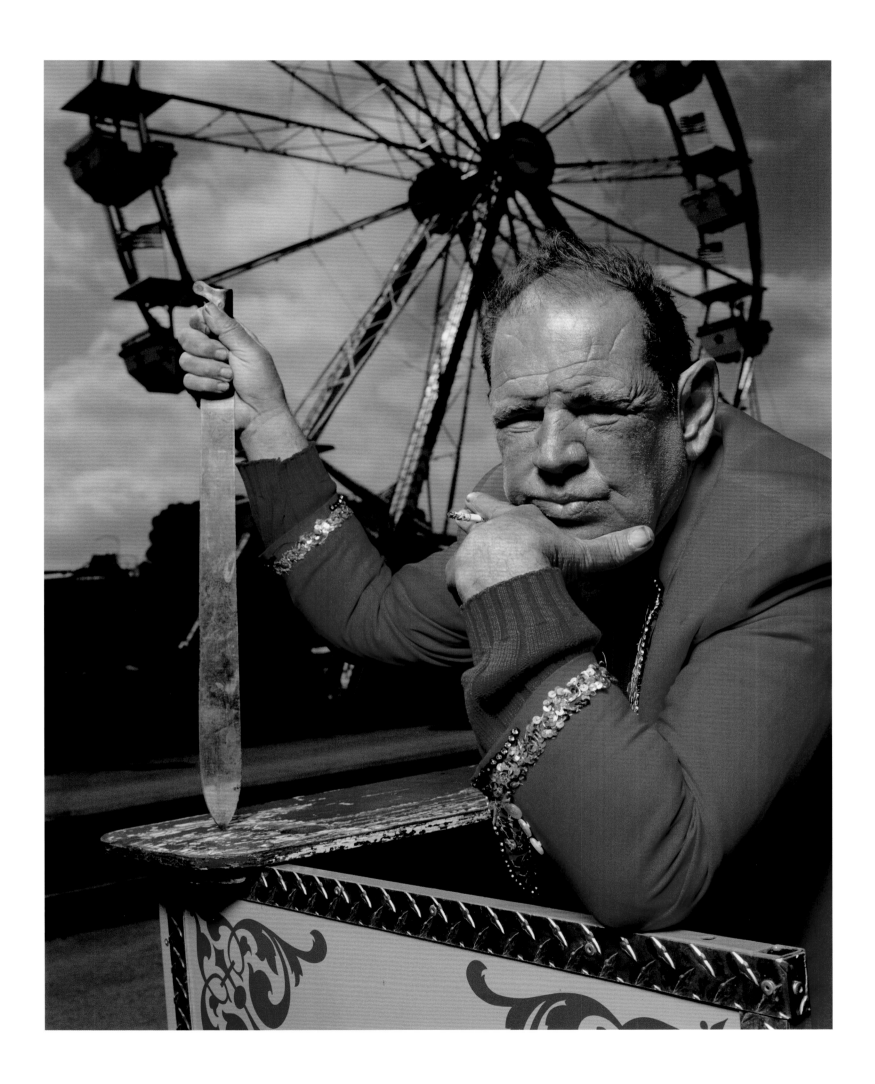

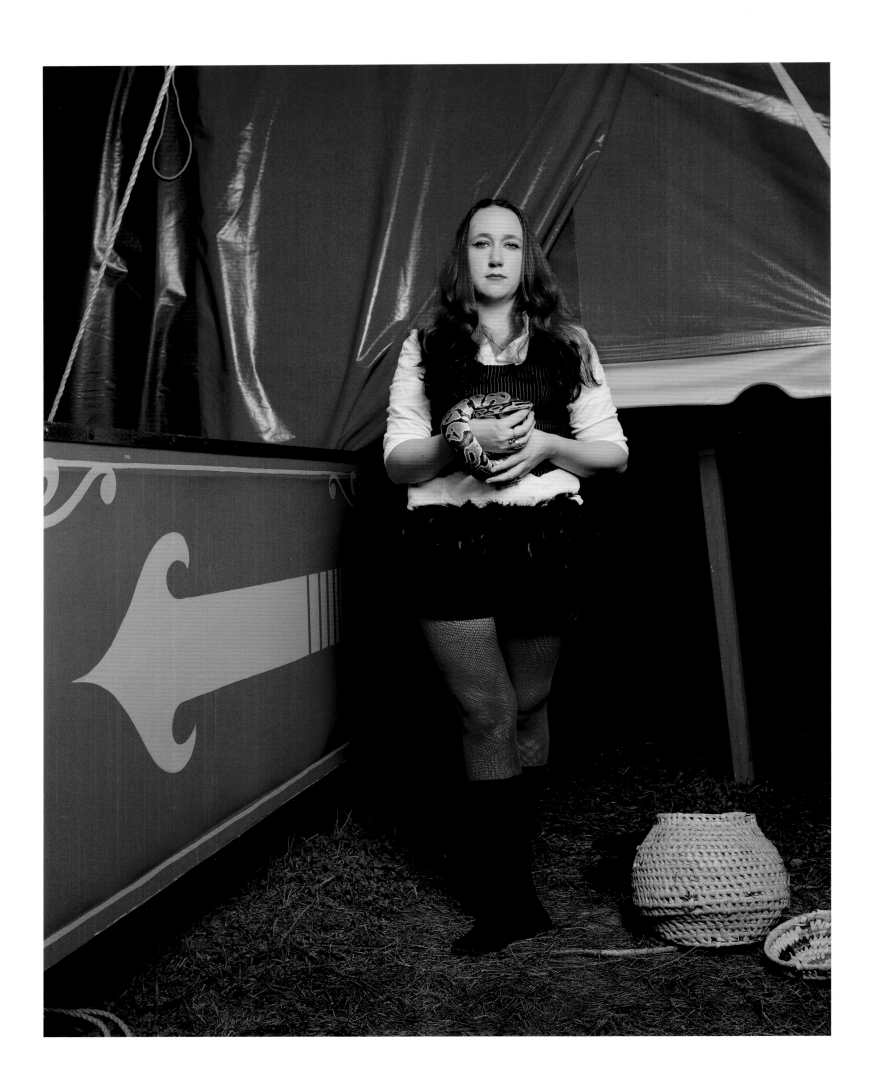

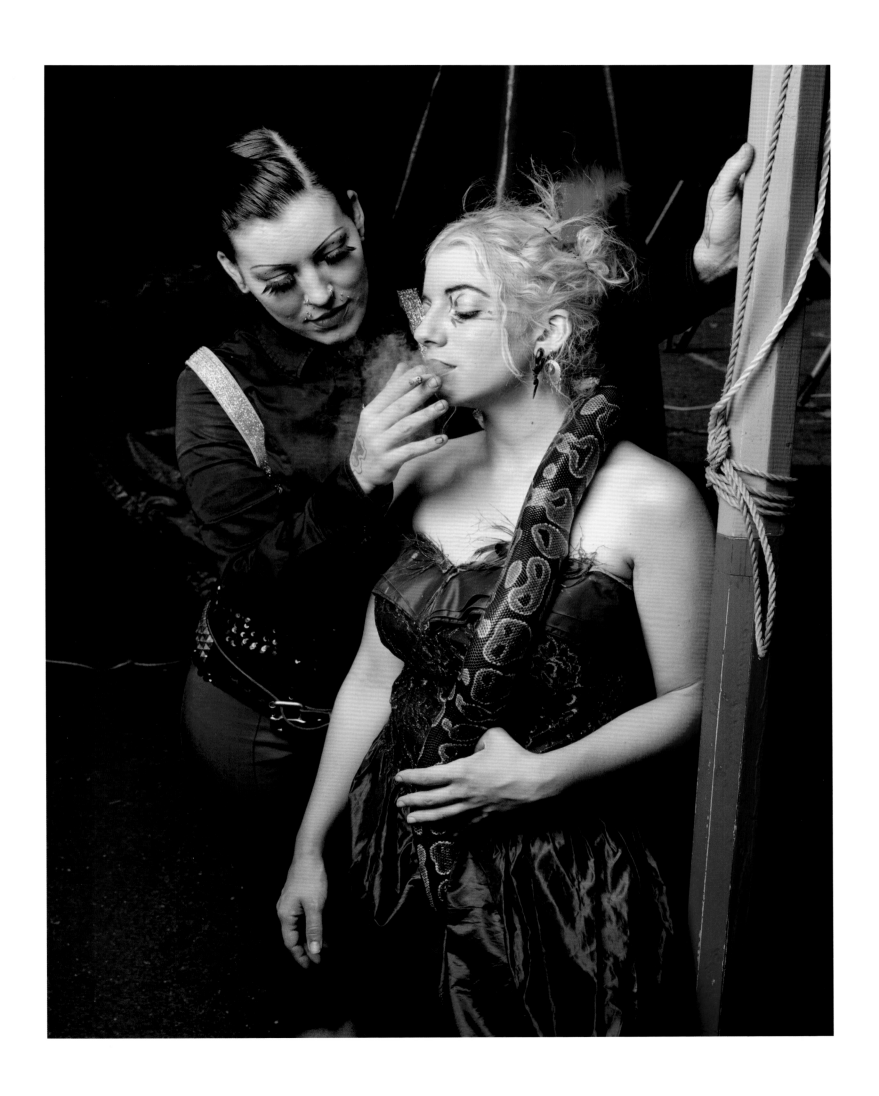

*W*e never argue over money; whether there was money or whether there wasn't. We never argue about anything important. I doubt I'd continue doing this without Ward. I wouldn't go out and face this much grief.

Chris

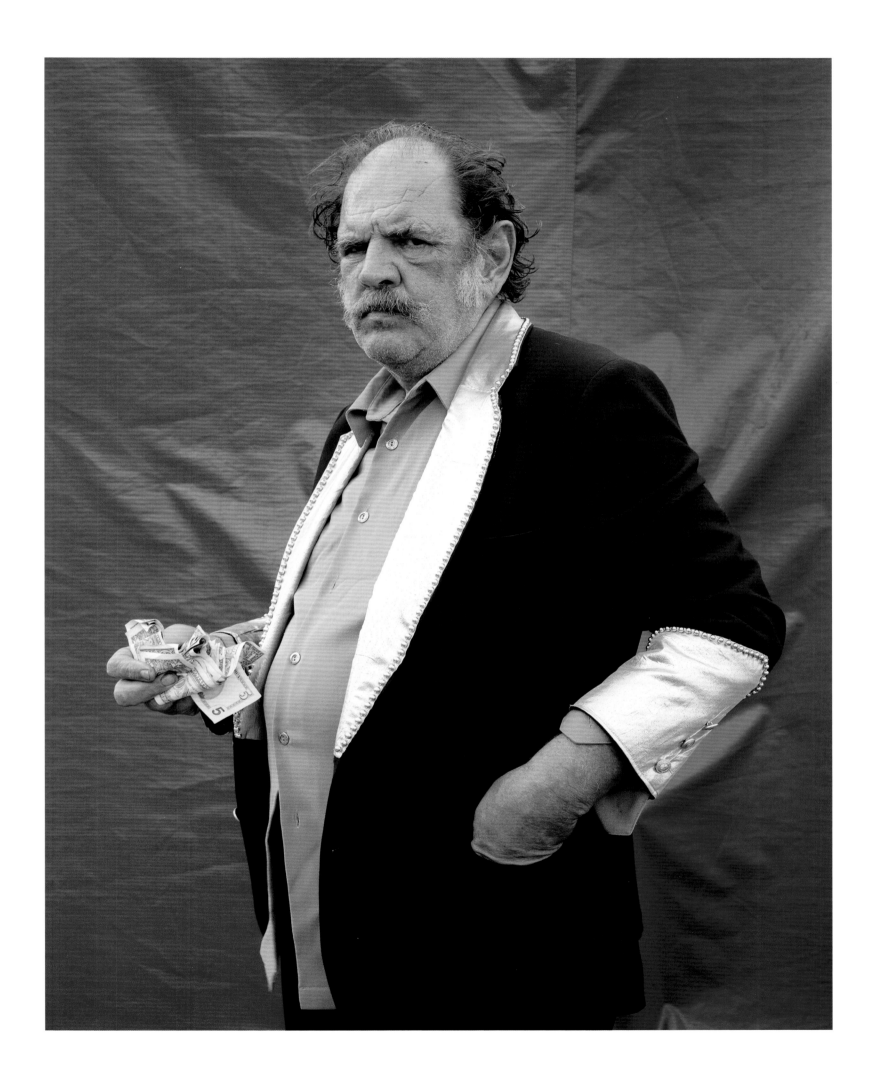

On the bally platform I tell the people that Pete has appeared in 37 motion pictures and over 200 television shows, which is quite an exaggeration, but Pete has heard this so many times he now actually believes it.

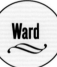

Ward

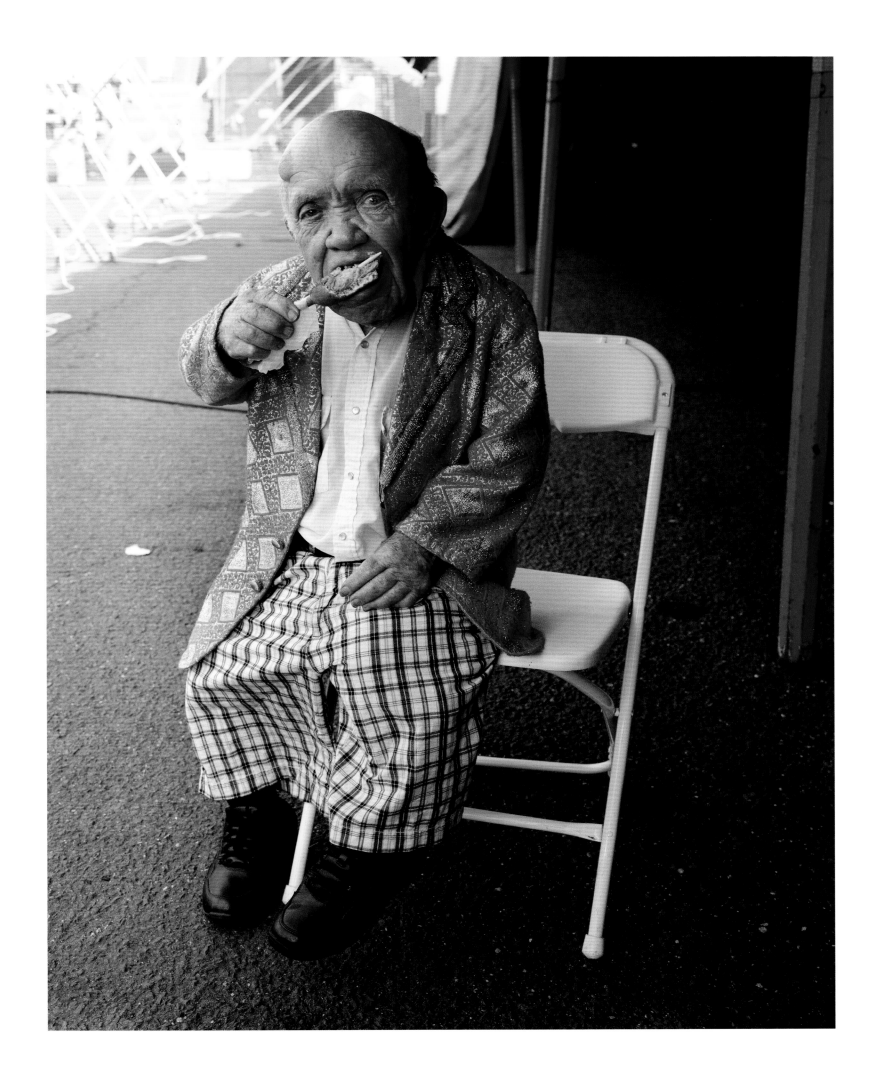

On a fairground, a pretty girl out front is essential. Sword swallowing, fire eating, and a pretty girl. That combination works. Without the front, you'd have no back.

Chris

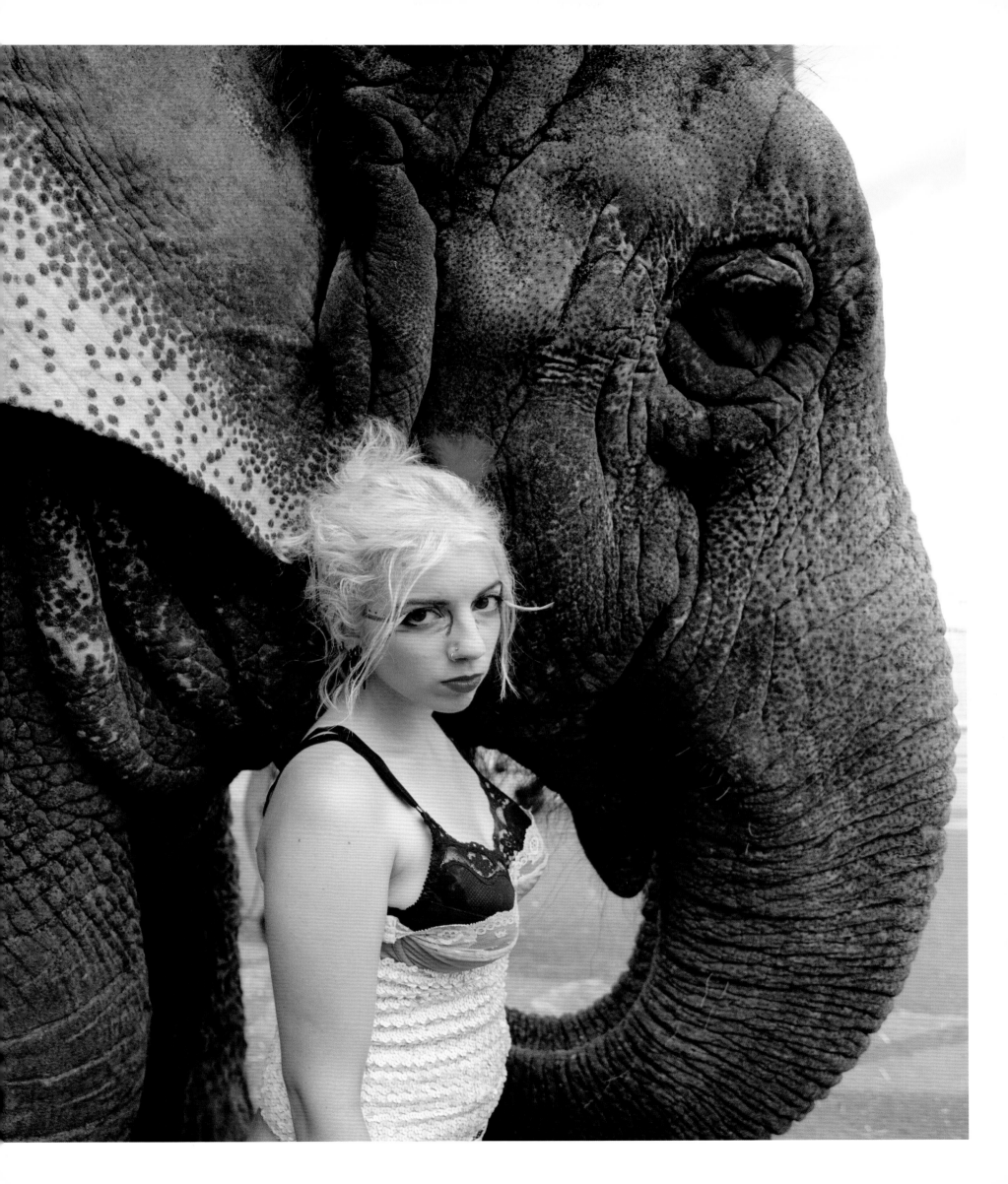

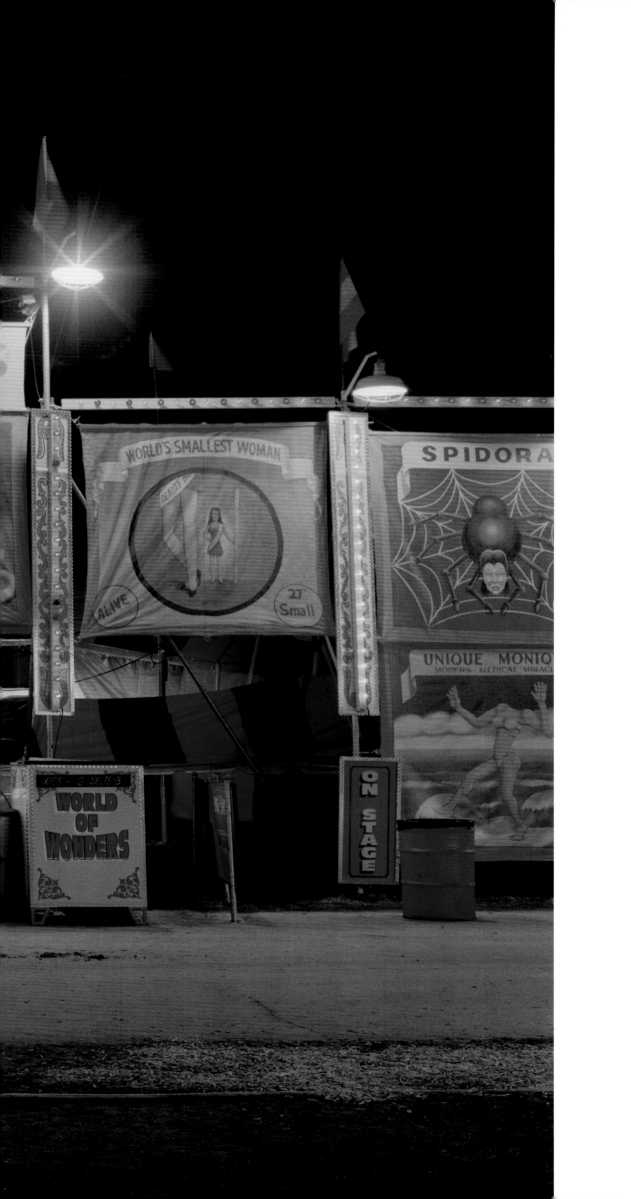

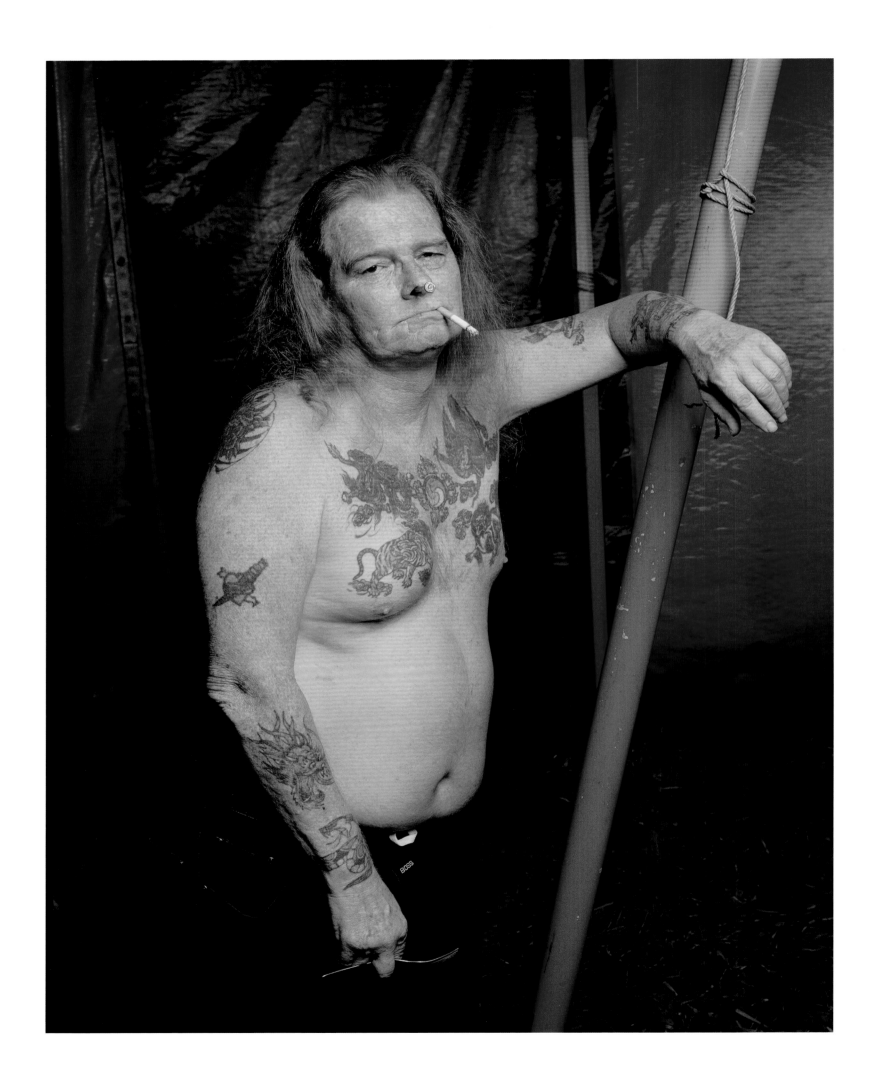

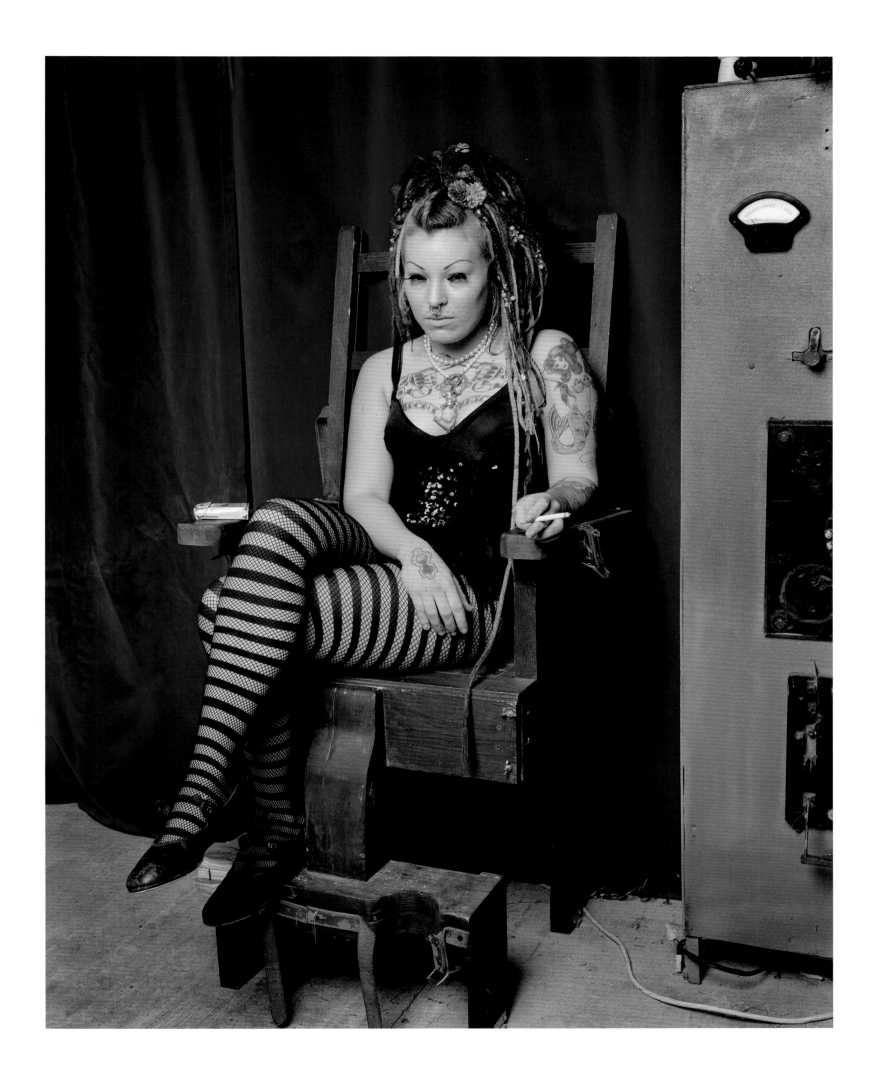

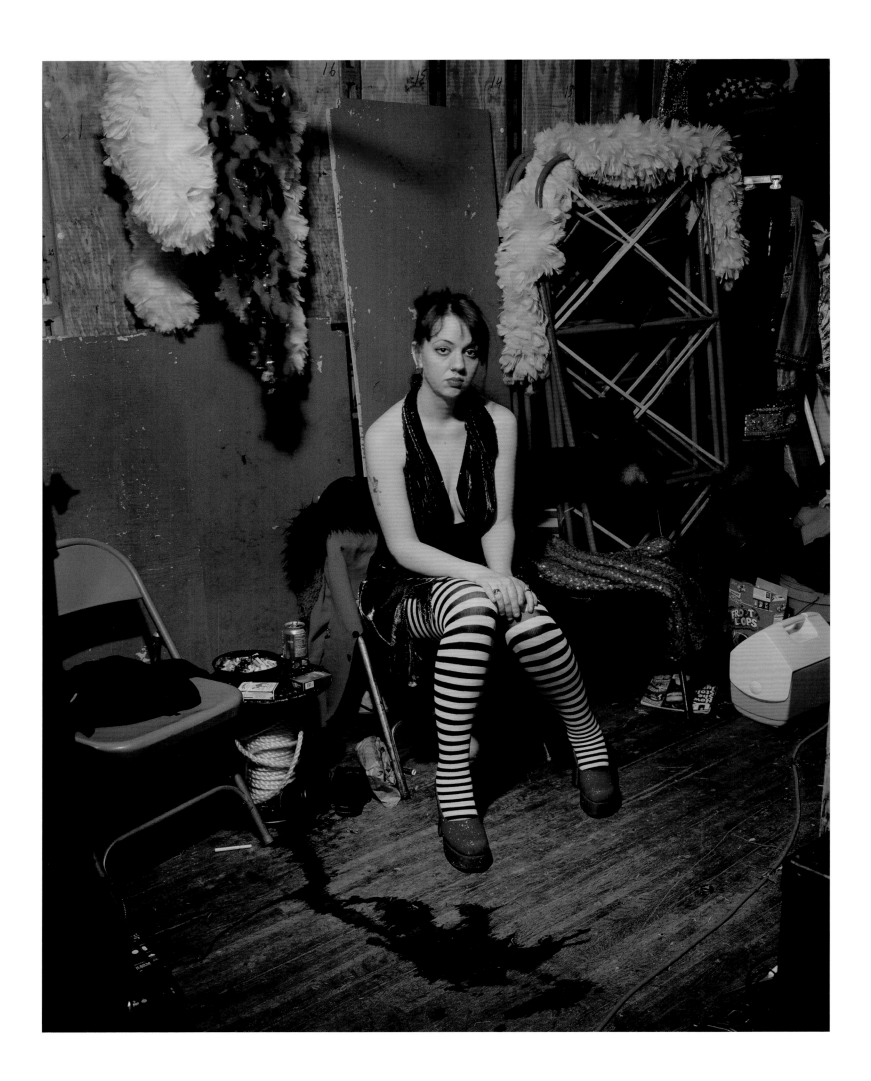

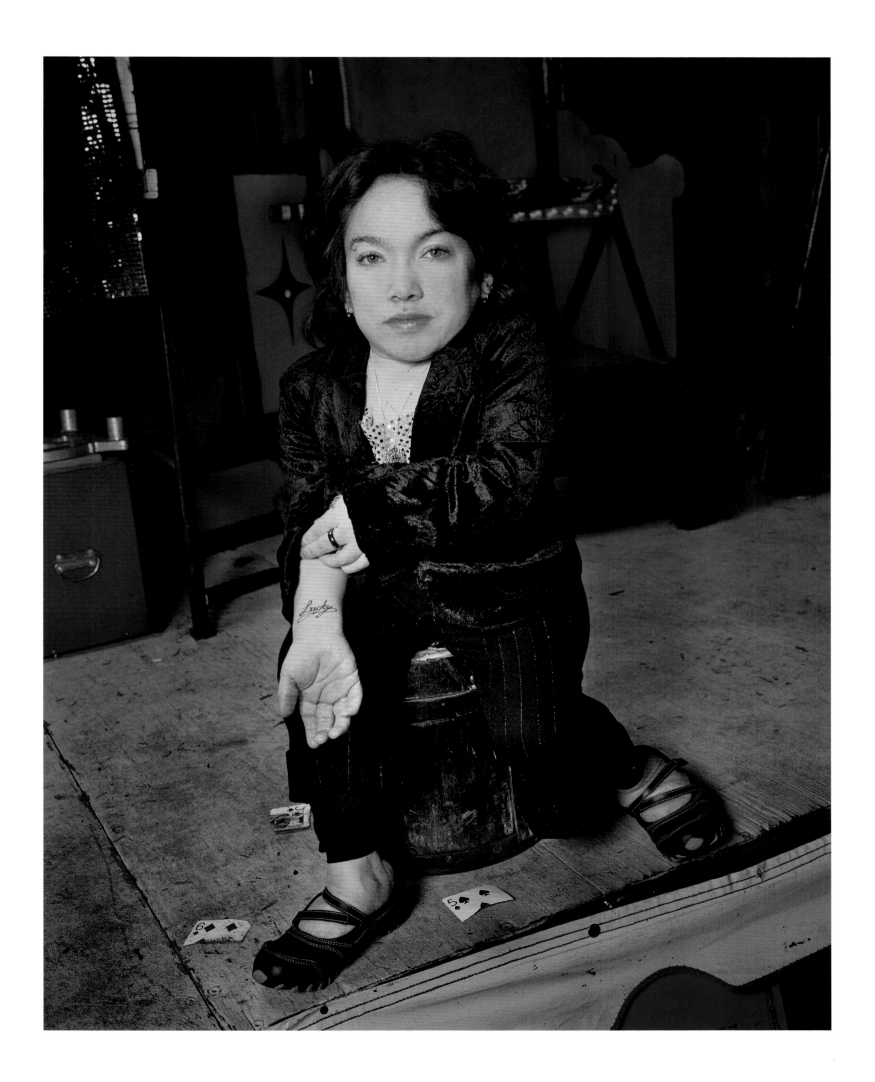

*L*ife out here isn't easy: it's long hours.

It is a hard life, but all life is hard.

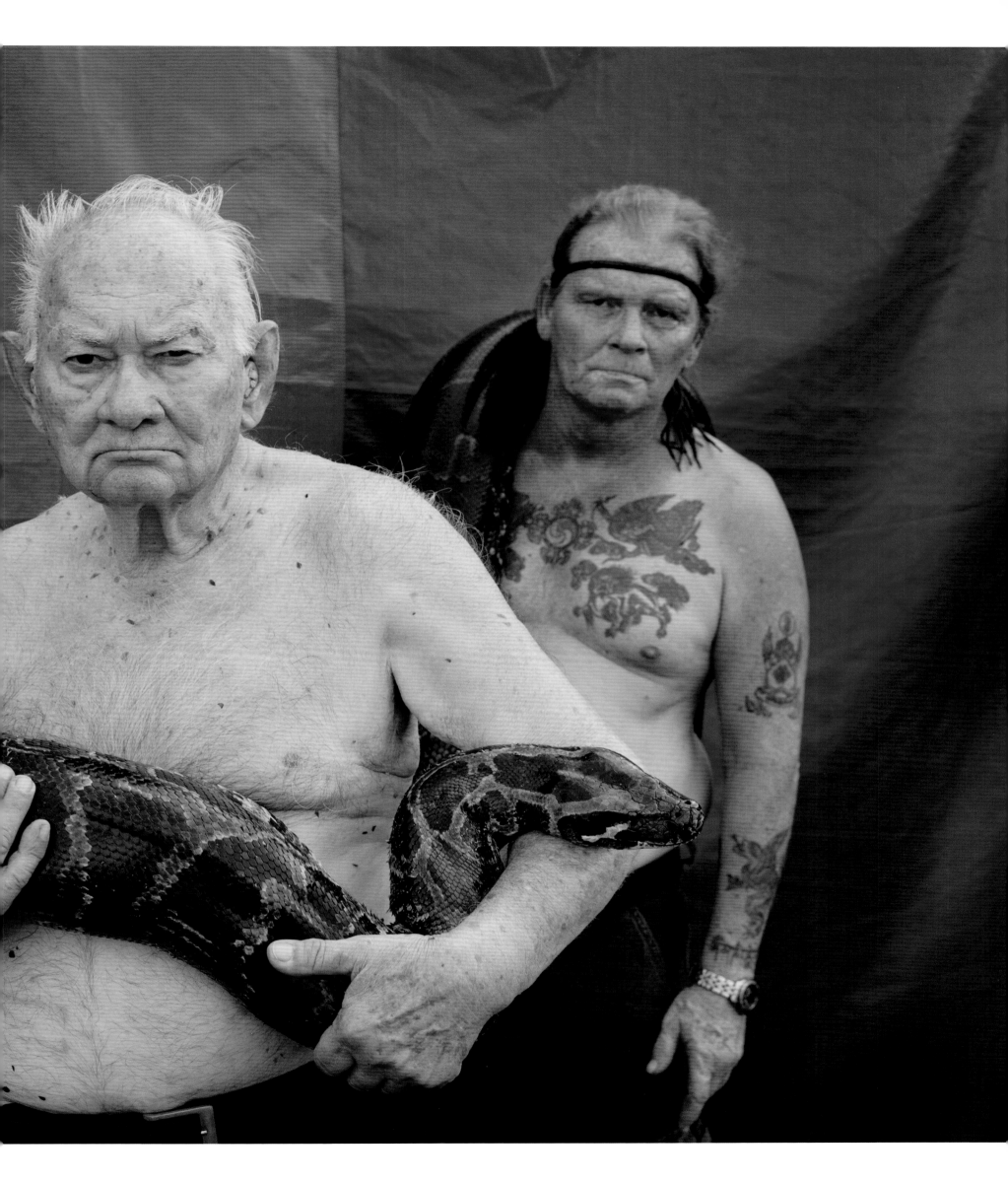

There's a bad connotation about the word *carnie*. There's a difference between a carnie and a showman. It's like the difference between chicken shit and chicken salad: they both come from the same animal but they're very different.

Chris

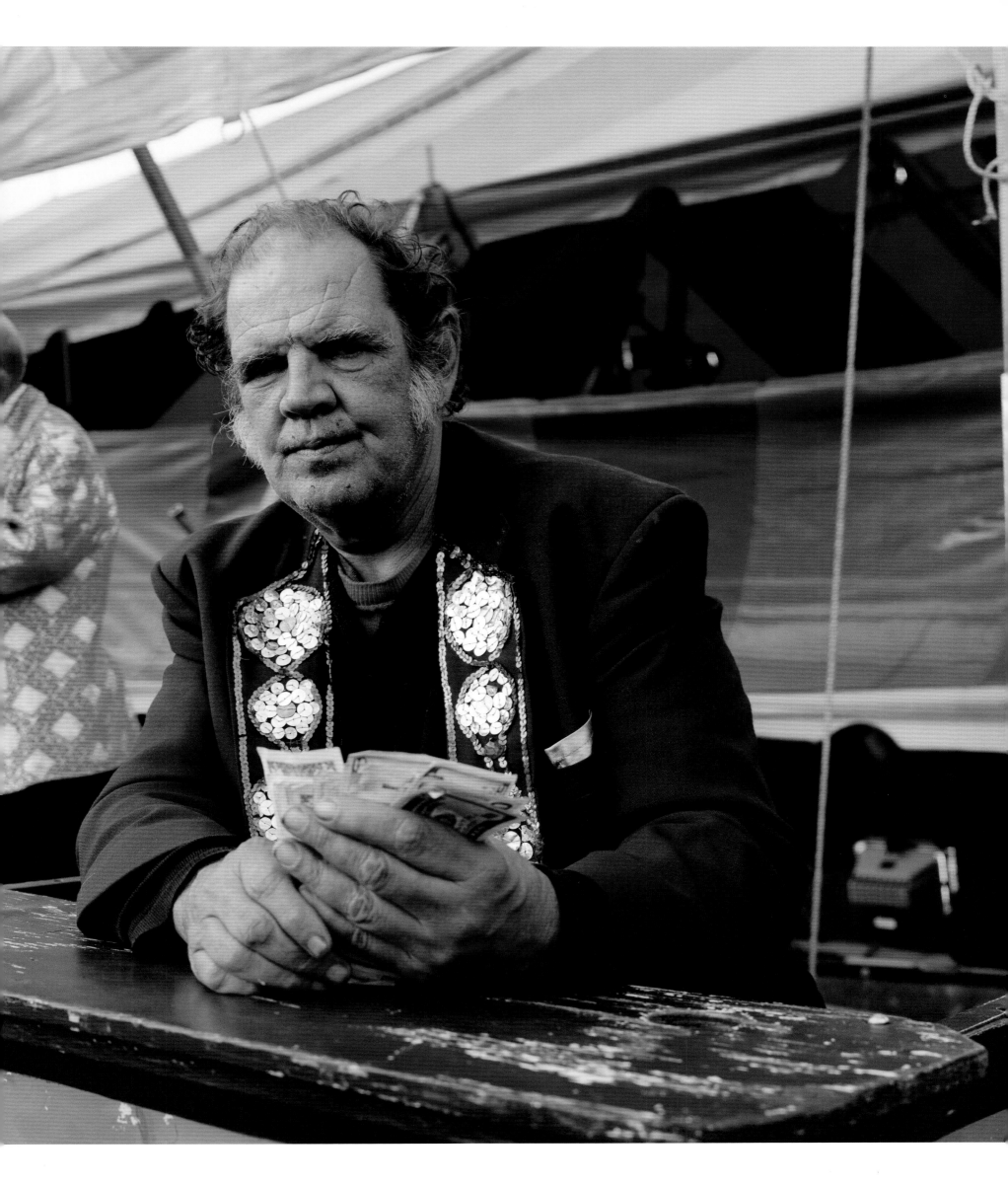

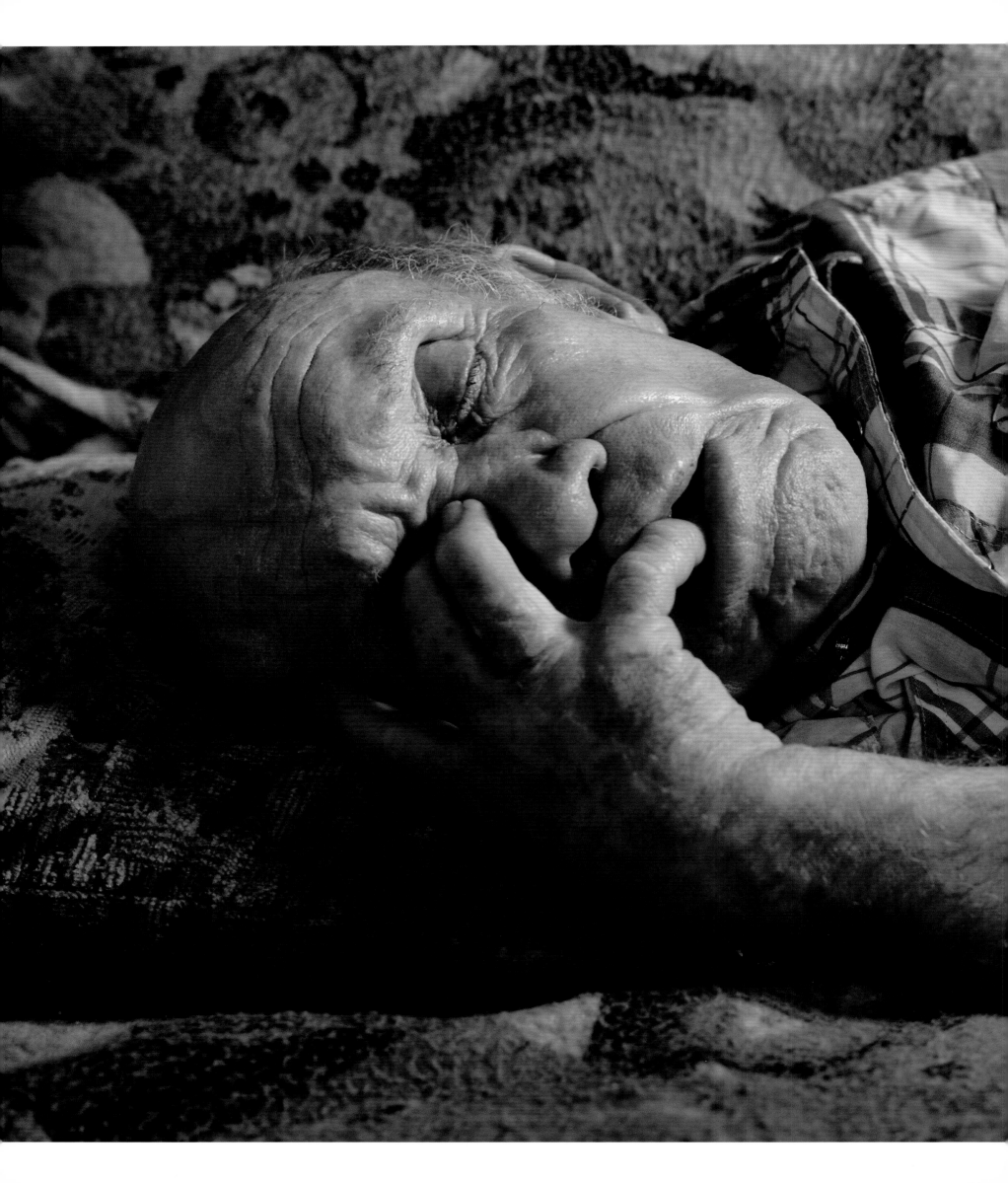

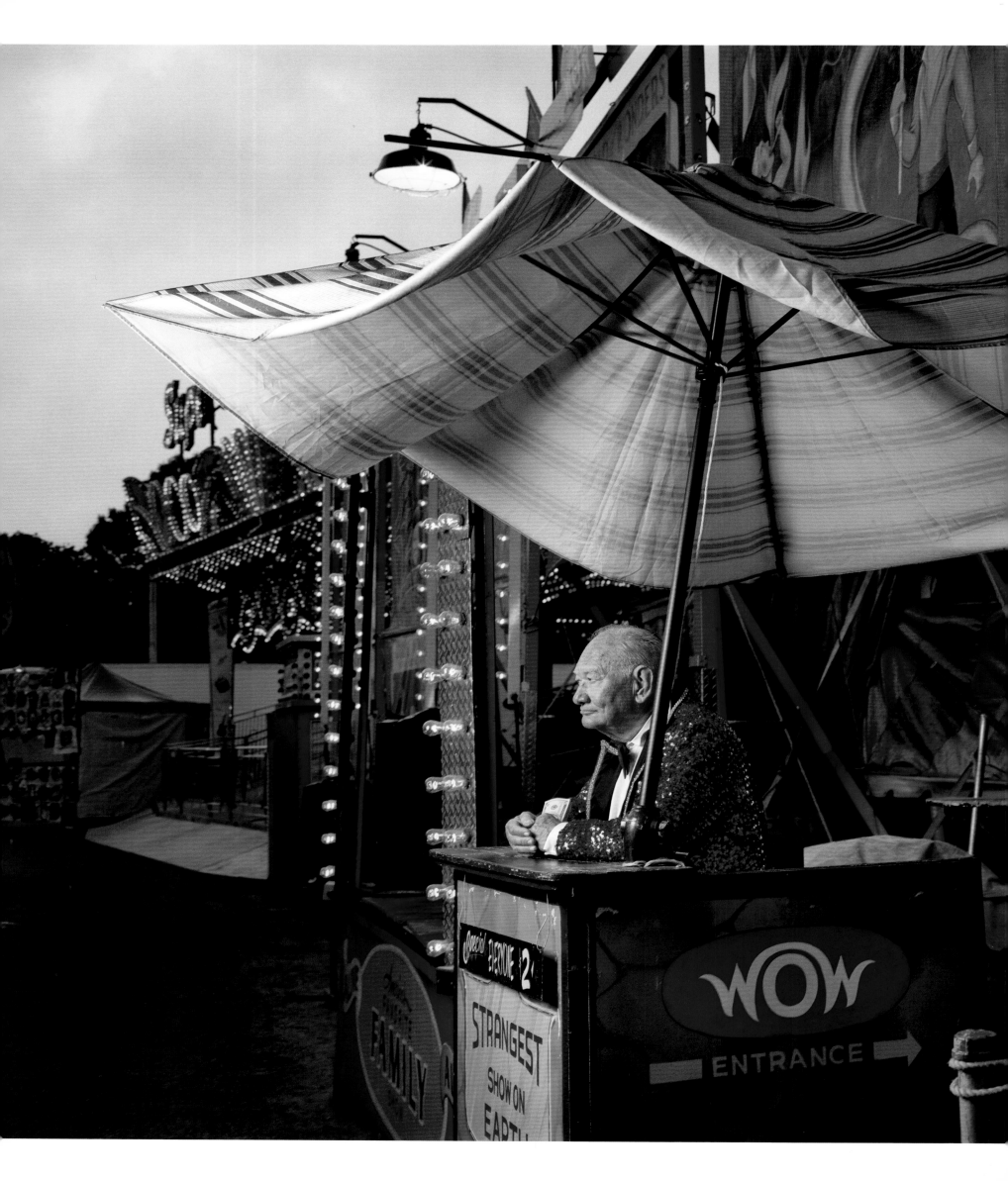

*W*ard is the last of the great showmen in the world. I love the man like he's my own father. He's the best there ever was.

Red

\mathcal{I} just want to be remembered for being fair and decent to people, and putting in my time.

Chris

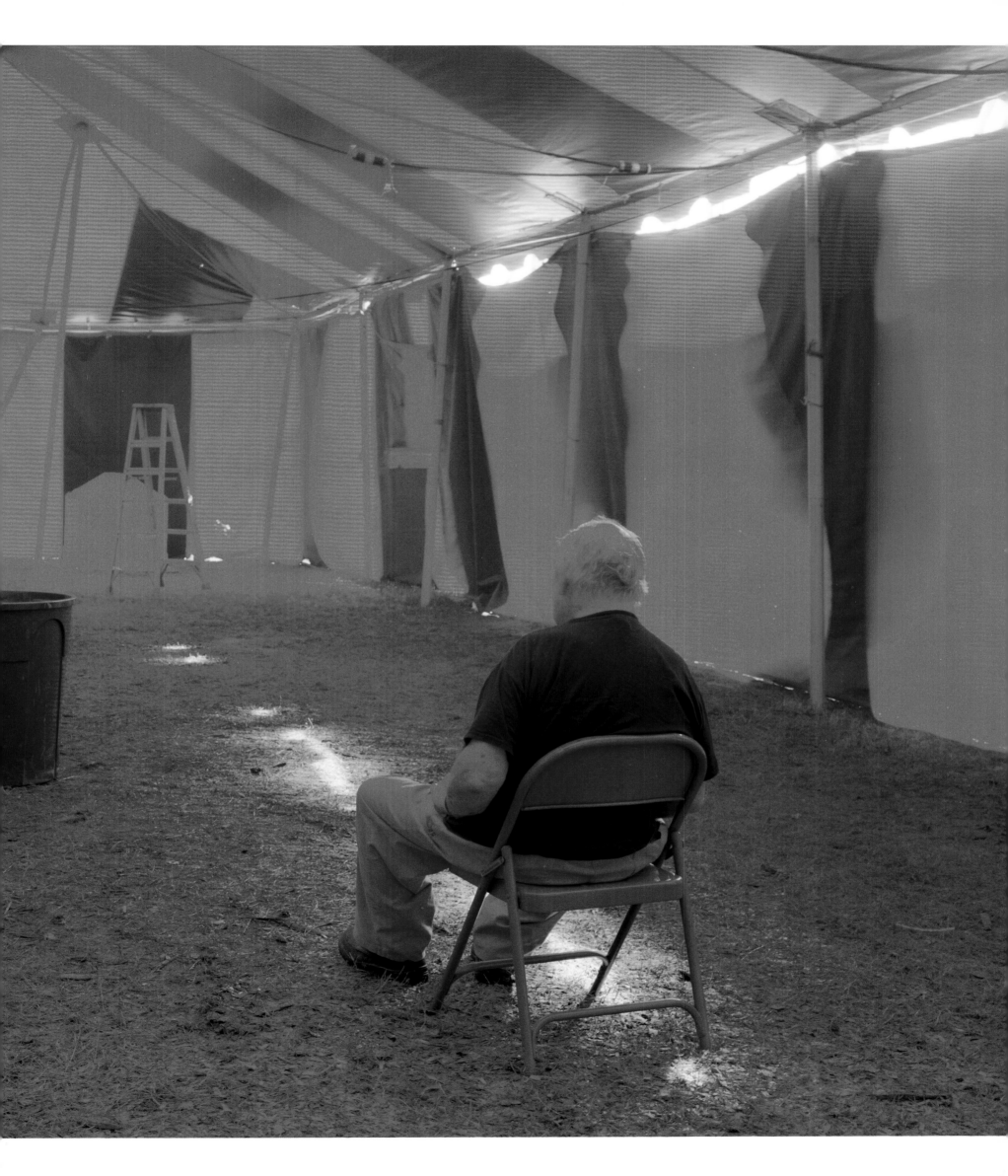

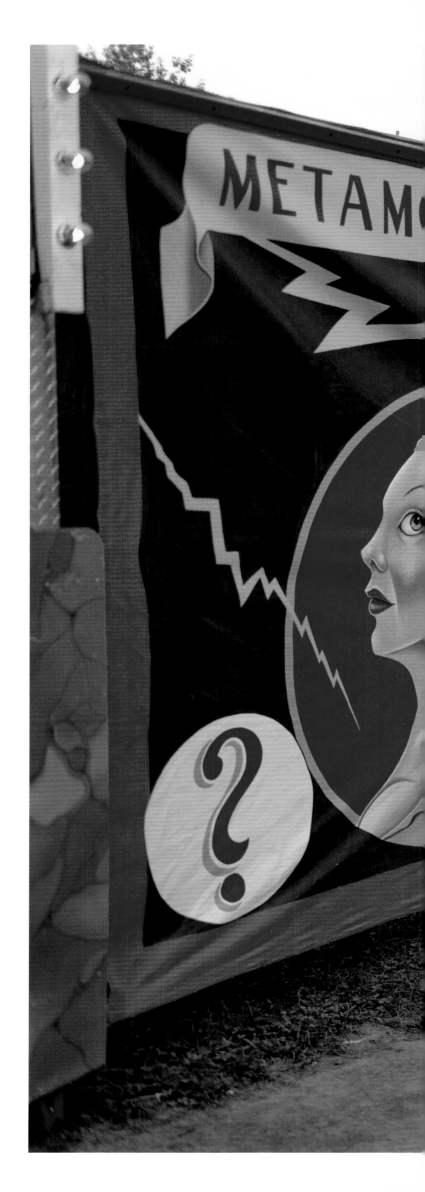

here is no fool like an old fool and when you get to be my age, I know damn well I'm an old fool. I'm a fool to be out there, to go through all this misery operating a show like this, putting up with the heat and the thunderstorms to have just a few moments on the stage. I have a wonderful memory. A wonderful memory is wonderful, but it is also a curse...because I remember all the bad things that I wish I could forget.

Ward

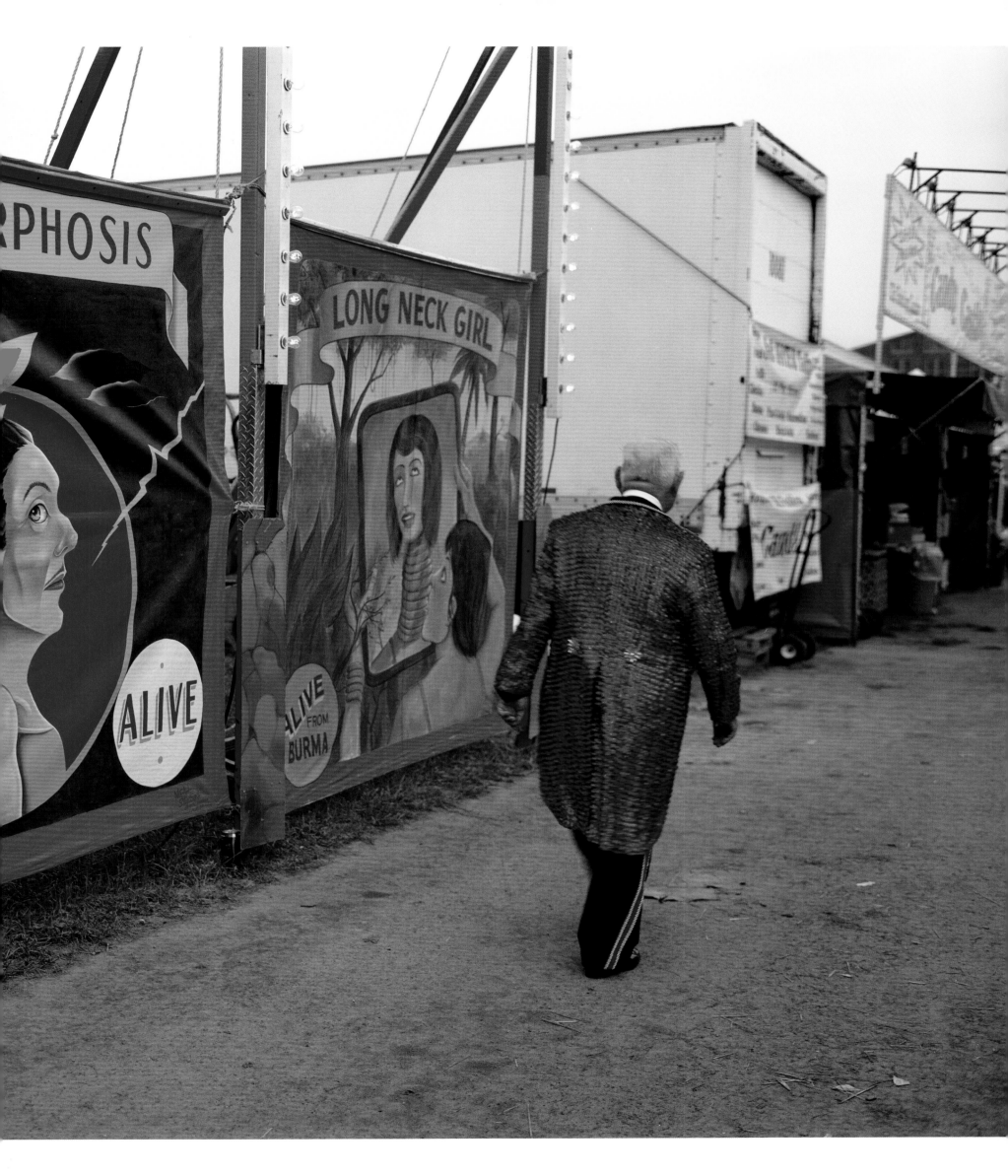

This book is dedicated to Marilyn Katz.

We would like to thank:

Ward Hall and Chris Christ for their kindness and generosity.
All performers who gave us their time.
Nick Del Pesco for his technical assistance.
Ben Diep, Color Space Imaging, New York, NY for film processing.
George Petty, Emily, Eduardo, Erica, Ariela Anhalt for their love and support.
Kiki Bauer and Ariana Barry for their beautiful design.
Daniel Power and Craig Cohen for their continued support of our work.

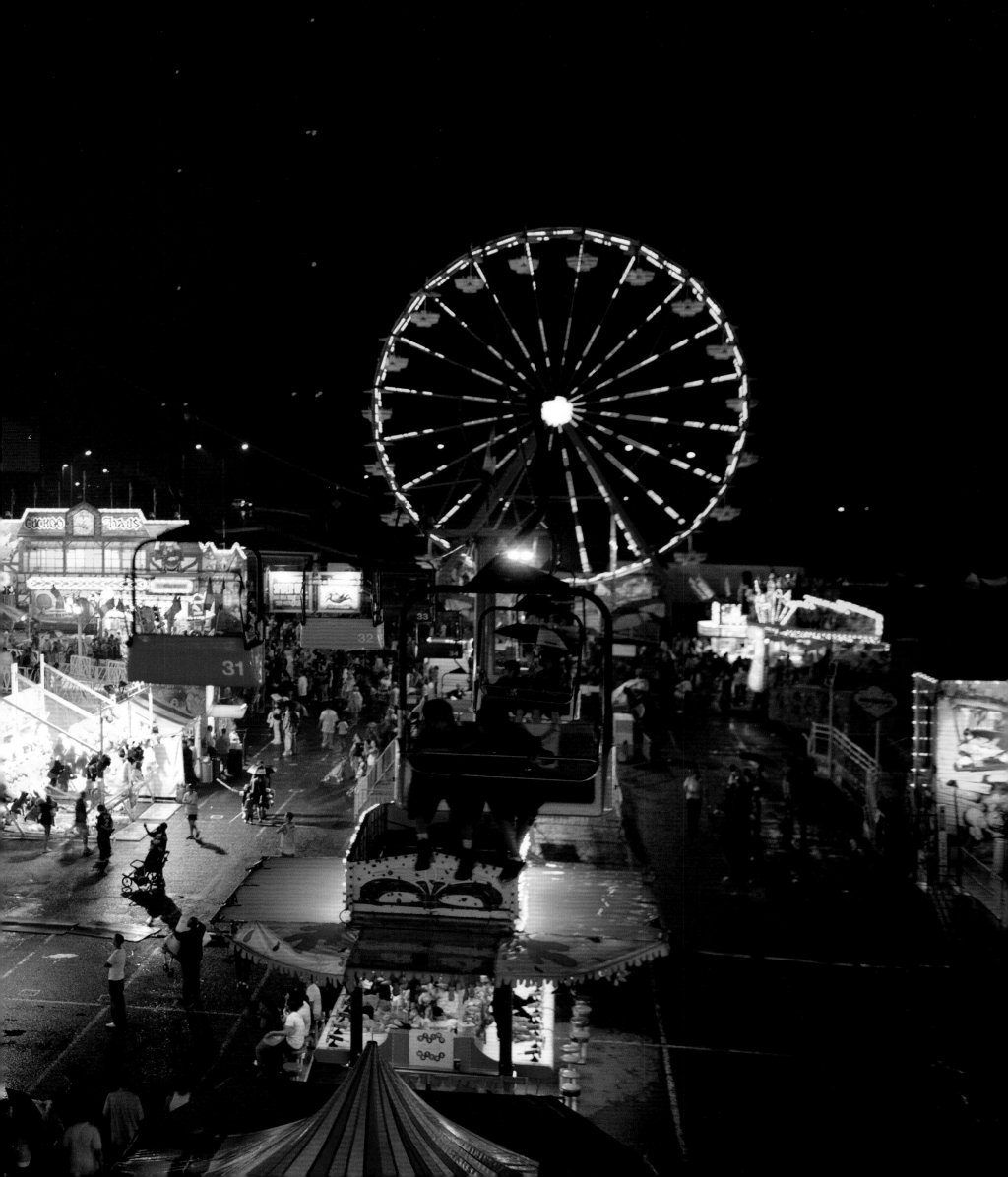

Jimmy Long at Ticket Booth,
Florida, 2007

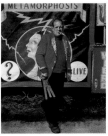

Ward Hall with Banners,
Florida, 2007

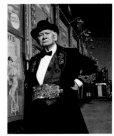

Chris Christ with Three Knives,
Florida, 2007

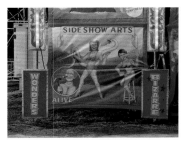

Sideshow Arts Banner,
Florida, 2007

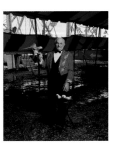

"The Old Pro" with Birds,
Florida, 2007

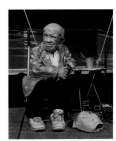

Poobah on Bally,
Pennsylvania, 2006

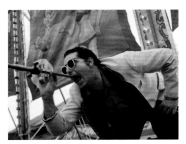

Tommy Breen Swallowing Sword,
New Jersey, 2008

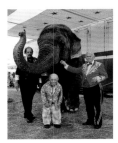

Chris, Poobah, Ward, and Elephant,
New Jersey, 2008

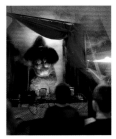

Man Eating Gorilla,
New Jersey, 2008

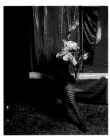

Chelsea Eating Fire,
Pennsylvania, 2006

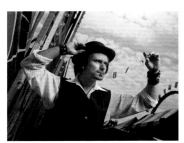

Elton with Razor Blades,
Pennsylvania, 2006

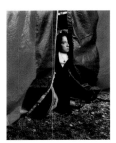

Firefly in Tent,
Florida, 2007

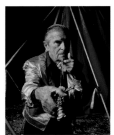

Johnny Meah with Sword,
Florida, 2007

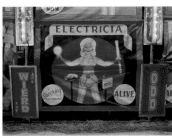

Electricia Banner,
Florida, 2007

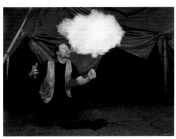

John Johnson Breathing Fire,
Florida, 2007

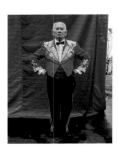

Ward Hall Standing with Tent,
New Jersey, 2008

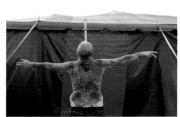

Red Stewart Swallowing Sword,
New Jersey, 2008

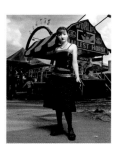

Veva with World's Smallest Horse,
Pennsylvania, 2006

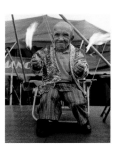

Poobah with Fire,
New Jersey, 2008

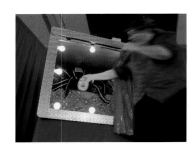

Spidora Act,
New Jersey, 2008

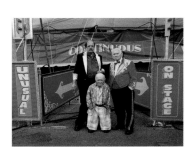

Chris, Poobah, and Ward in front of Tent,
New Jersey, 2008

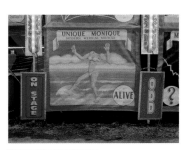

Unique Monique Banner,
Florida, 2007

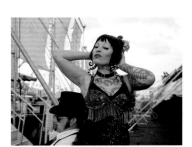

Chelsea with Mike Vitka,
New Jersey, 2008

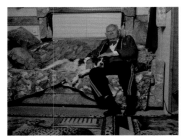

Ward and Dog inside Trailer,
Pennsylvania, 2006

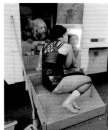

Chelsea and Natalie before the Show,
New Jersey, 2008

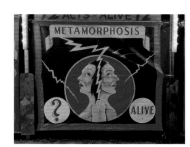

Elton Shaving,
Florida, 2007

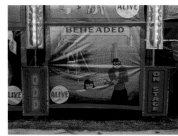

Beheaded Banner,
Florida, 2007

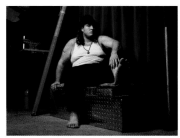

James on Bed of Nails,
New Jersey, 2008

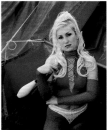

Elena with Juggling Clubs,
Florida, 2007

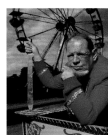

Chris with One Knife,
Florida, 2007

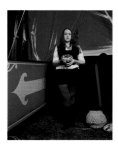

Metamorphosis Banner,
Pennsylvania, 2006

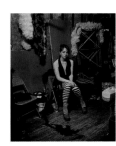

April with Snake,
Pennsylvania, 2006

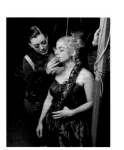

Chelsea and Natalie with Snake,
New Jersey, 2008

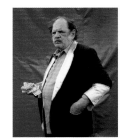

Chris with Money,
New Jersey, 2008

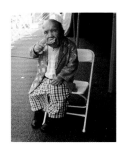

Poobah Eating Corn Dog,
New Jersey, 2008

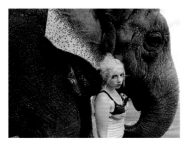

Natalie and Elephant,
New Jersey, 2008

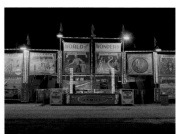

World Of Wonders Banners,
Florida, 2007

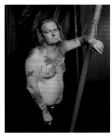

Red Stewart with Nail in Nose,
Pennsylvania, 2006

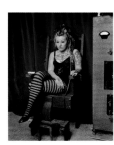

Chelsea in Electric Chair,
Pennsylvania, 2006

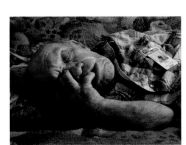

Rain in Trailer,
Florida, 2007

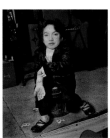

Firefly Showing Tattoo,
Florida, 2007

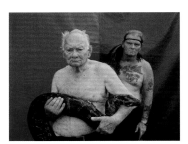

Ward and Red Holding Snake,
New Jersey, 2008

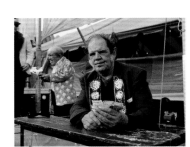

Chris at Ticket Booth,
Pennsylvania, 2006

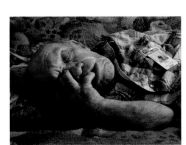

Poobah Sleeping,
New Jersey, 2008

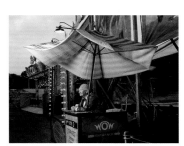

Ward under Umbrella,
Pennsylvania, 2006

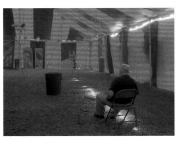

Jimmy Long Sitting in Tent,
Florida, 2007

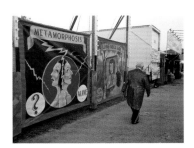

Ward Walking Away,
Pennsylvania, 2006

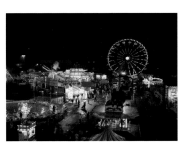

Fairground at Night,
New Jersey, 2008

WORLD

of

WONDERS

Published in the United States by powerHouse Books,
a division of powerHouse Cultural Entertainment, Inc.
37 Main Street, Brooklyn, NY 11201-1021
telephone 212 604 9074, fax 212 366 5247
e-mail: worldofwonders@powerHouseBooks.com
website: www.powerHouseBooks.com

First edition, 2009

Library of Congress Cataloging-in-Publication Data:

Katz, Jimmy.
 World of wonders / photographs by Jimmy and Dena Katz.
 p. cm.
 ISBN 978-1-57687-492-9 (hc.)
 1. Circus--United States--Pictorial works. 2. Circus
performers--Portraits. 3. Circus in art. 4. Portrait photography. I.
Katz, Dena. II. Title.
 GV1816.K38 2009
 779'.20922--dc22
 2009075065

Hardcover ISBN 978-1-57687-492-9

Printing and binding by Midas Printing Inc., China

For more information about Jimmy and Dena Katz, please visit www.jimmykatz.com

A complete catalog of powerHouse Books and Limited Editions is available upon request; please call, write, or visit our website.

10 9 8 7 6 5 4 3 2 1

Printed and bound in China